ARIZONA
OUTLAWS and LAWMEN

ARIZONA
OUTLAWS and LAWMEN

· GUNSLINGERS, BANDITS, HEROES AND PEACEKEEPERS ·

MARSHALL TRIMBLE

THE
History
PRESS

Published by The History Press
Charleston, SC 29403
www.historypress.net

Copyright © 2015 by Marshall Trimble
All rights reserved

First published 2015
Second printing 2015

Manufactured in the United States

ISBN 978.1.62619.932.3

Library of Congress Control Number: 2014959950

This book is dedicated to my beloved grandson, Liam, and granddaughter, Annabella Rose. Although a few thousand miles separate us, you're always on my mind.

CONTENTS

Introduction 9

1. Buckey O'Neill and the Train Robbers 11
2. Jim Roberts: The Pleasant Valley War's Top Gun 17
3. The Vanishing Train Robbers 36
4. Commodore Perry Owens: Bringing Law and Order
 to Apache County 39
5. Climax Jim: Arizona's Lady Godiva 62
6. Texas John Slaughter 67
7. George Ruffner: Sheriff of Old Yavapai 73
8. Burt Mossman: Captain of the Arizona Rangers 85
9. Pearl Hart: The Girl Bandit 99
10. Hucksters, Hustlers, Swindlers and Bamboozlers 104
11. Bad Boys of Cochise County 114

Bibliography 131
Index 137
About the Author 141

INTRODUCTION

People need heroes, and if they don't have them they make them up. The Old West didn't have that problem; it had an abundance of the real deal, and in that land of giants, the ones who stood head and shoulders above the rest were the gunfighters. They were America's rendition of King Arthur's Knights of the Round Table. Some were knights-errant on horseback, and some weren't.

Why do these hard-riding heroes who lived and died by the gun continue to hold our fascination? Maybe it's because they take us outside of ourselves and enable us to escape the drudgery of our daily lives. We're drawn to them because we see them as rebels who weren't afraid to take on the establishment. We admire those who live on the edge, those who defy authority. In an odd way, they were the manifestation of the traits that made America great: self-reliance, independence, resourcefulness, toughness and courageousness. They were huge myths with a whole lot of reality thrown in.

We have a normal hunger for a heroic past, and the West provides that. The West was a land of superlatives and open spaces and a place where men and women could reinvent themselves.

Arizona was the last refuge of the restive lawmen and desperadoes of the Old West. Its wild, untamed country, lack of good roads and proximity to the Mexican border made it ideally suited to men riding the "Owl Hoot Trail." The rich boomtowns, stagecoaches and railroads carrying express boxes loaded with gold coins, along with large herds of cattle, were easy pickings in the remote regions by bands of outlaws and cow thieves.

Introduction

In order to bring law and order to the last frontier, it took a brave, hardy breed to pin on a badge and challenge the bands of outlaws, many of whom were psychopaths and sociopaths who preyed on the weak and often killed without remorse. Sworn to keep the peace, they endured hardships and hunger, and sometimes they died in the line of duty.

1

BUCKEY O'NEILL AND THE TRAIN ROBBERS

Arizona attracted a number of flamboyant characters during its territorial years, but none was more colorful than William O. "Buckey" O'Neill. His good looks and witty charm made him a darling of the ladies, and his gallant charisma made him a natural leader of men. He made his reputation as a newspaperman, judge, politician, lawman, soldier and go-for-it gambler. His nickname came from "bucking the tiger," or betting against the house in the popular game of faro on Prescott's famed Whiskey Row.

He stood nearly six feet tall with a stylish mustache; dark, handsome looks; and a devil-may-care persona that attracted legions of admirers. Gregarious, witty and self-confident, he could quote Lord Byron at the drop of a hat and was fearless in the face of danger.

Buckey was born in St. Louis, Missouri, and was only nineteen years old when he rode into Phoenix in 1879. Seeking adventure, he soon headed for Tombstone during the heyday of Wyatt Earp, Doc Holliday and Johnny Ringo but returned to Phoenix three years later to become a deputy city marshal under the famed Henry Garfias. His next stop was Prescott, where in 1888 he got into politics and was elected sheriff of Yavapai County.

On a cold March day in 1889, not long after Buckey had taken the oath of office, four Hash Knife cowboys—Bill Sterin, John Halford, Dan Harvick and J.J. Smith—decided to up their station in life by robbing the Atlantic and Pacific Eastbound No. 2 passenger train. They planned to pull the

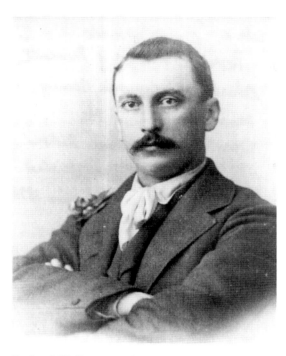

Buckey O'Neill was one of Arizona's most colorful characters. The swashbuckling Irishman was a newspaperman, politician, mayor of Prescott and sheriff of Yavapai County. *Courtesy of Southwest Studies Archives.*

heist while it was stopped to replenish its wood box at Canyon Diablo, twenty-four miles west of Winslow.

The train robbers came out of the dark shadows of the section house, poked their six-guns in the faces of the crew and forced open the express safe, taking some $7,000 in cash, pocket watches and a set of diamond earrings. They then rode off into the night in a snowstorm. The plan was to ride south a few miles to deceive the posse and then turn north and head for Utah.

About five miles south of Canyon Diablo, they stopped to divide up the loot. Among the booty was a pair of diamond earrings. Smith pried the diamonds loose from their settings and dropped them into his pocket, where he proceeded to forget about them. Later, he unwittingly scraped some tobacco crumbs and the diamonds out of his pocket and put them in his pipe. Afterward, he knocked the ashes out on his boot heel, and with them went the diamonds.

Canyon Diablo was in Yavapai County back in those days before Coconino County was created and was about the same size as the entire state of New York. Buckey had been in office only three months, and this would be his first real test as a lawman.

O'Neill and his deputy, Jim Black, were already in Flagstaff when the robbery occurred. They were soon joined by special deputy Ed St. Clair of Flagstaff and two railroad detectives, Carl Holton and Fred Fornoff.

They picked up the outlaws' trail in the high desert north of Flagstaff and followed it until they met a Navajo woman who told them four men

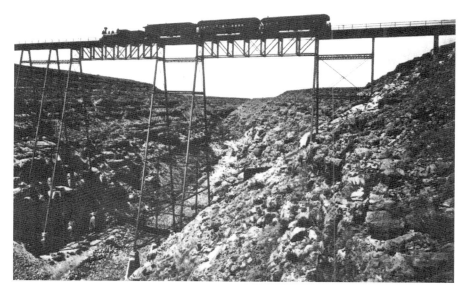

A Santa Fe passenger train rolls over the Canyon Diablo during the 1880s. *Courtesy of Southwest Studies Archives.*

had run off that morning with a mutton she'd just skinned. Buckey sent a young Navajo boy to Winslow to ask the telegrapher to send messages to the villages in southern Utah to be on the lookout.

Meanwhile in Utah, the four outlaws arrived at the small Mormon community of Cannonville, located in a valley just east of Bryce Canyon. Word had reached residents to be on the lookout for the four desperadoes, and not long after, they came riding boldly into town.

The Mormons treated them with reserved kindness, fed them and offered them a place to sleep. The four hard-looking strangers cautiously accepted the hospitality and settled in for the night. While the trail-weary train robbers were sleeping, the local constable, along with a posse of farmers, got the drop on them, but J.J. Smith was able to turn the tables. He nabbed the town patriarch, who then ordered the citizens to throw down their guns. The marauders took their weapons, stole some supplies and rode out of town firing indignant shots into the air.

When the posse arrived at Lee's Ferry, they learned the outlaws had crossed two days earlier, headed north for Wahweep Canyon at today's Lake Powell and then turned south back toward Lee's Ferry, and that's

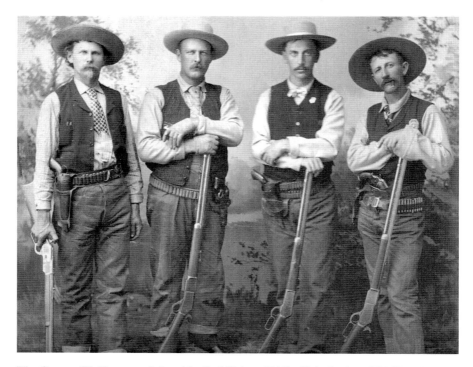

The Canyon Diablo posse. *Left to right*: Carl Holton, Ed St. Clair, Buckey O'Neill and Jim Black. *Courtesy of Southwest Studies Archives.*

where the posse caught up with them. They came upon a deserted camp, but fresh tracks and warm ashes from a campfire meant the train robbers weren't far away. The train robbers' tracks led into a box canyon. They had unwittingly gotten themselves literally boxed in. Surrounded on three sides by precipitous cliffs and a posse in front, the four men spurred their mounts and charged toward the lawmen with guns blazing. Buckey's horse was shot out from under him in the first round of fire, pinning him beneath.

The posse men quickly dismounted and pried Buckey from under his horse. He slid his Winchester from the scabbard and continued to return fire, the bullets ricocheting off the canyon walls and peppering the outlaws with sandstone.

The gunfire had frightened the outlaws' horses, causing them to stampede into the brush and leaving the gang afoot. Halford and Sterin were captured first. Smith and Harvick made a run for it, leaping over a bluff and bouncing down to the canyon floor.

The pair was able to dodge the lawmen the rest of that day and through the night, crawling through brush and over rocky crevasses. Finally, footsore,

thirsty and tired, they arrived at a small watering hole, where they bathed their swollen feet in the cool water. They were getting ready to leave when a shot crashed nearby, showering them with pieces of rock. Afoot, weary and dispirited, the last two outlaws threw down their guns and surrendered.

By the time one of the Old West's greatest pursuits was over, Buckey and his posse had been in the saddle three weeks and had ridden over six hundred miles.

At Panguitch, Utah, the local blacksmith put leg irons on the bandits. Then they took the long way back to Prescott by way of Salt Lake City and Denver and then headed home on the Santa Fe Railroad.

On the way, J.J. Smith managed to slip out of his shackles and jump off the train, but the other three arrived in tow.

Buckey was hailed as a hero by the territorial governor and the citizens, but when he submitted his travel expenses, all out of pocket, the county board of supervisors refused to pay the whole amount, saying that by chasing the outlaws into Utah, he'd gone out of his jurisdiction. Buckey sued them and won.

Buckey O'Neill would go on to even greater glory. He was mayor of Prescott in 1898 when war broke out with Spain. Arizonans eagerly volunteered to join the First United States Volunteer Cavalry, a brainchild of the colorful Teddy Roosevelt. They became better known as the Rough Riders and would become the most celebrated unit in the war.

Buckey was selected as captain of Company A, made up mostly of men from northern Arizona. The Rough Riders were a mixed bag of rogues, short on discipline and long on energy, but in no time at all they became a crack fighting outfit, and Buckey O'Neill was their most popular officer. His noble sense of justice made him a favorite of the enlisted men. The handsome Irishman became the personification of the *beau ideal* Rough Rider.

The Arizona Rough Riders fought in the two major battles of the war in Cuba: Las Guasimas and the San Juan Heights. In both fights, Buckey stood defiantly in front of the lines as if he was challenging the Spanish snipers to shoot him. More than once he declared, "The Spanish bullet is not molded that will kill me."

Captain O'Neill had the luck of the Irish with him right up to the end. He staunchly believed an officer should always stand and face the enemy. Despite pleading from his troops, he refused to take cover in a trench.

Buckey continued walking up and down the line shouting encouragement to his troopers. Around ten o'clock on the morning of July 1, 1898, a random shot from a Spanish sniper ended the life of Buckey O'Neill. The men of

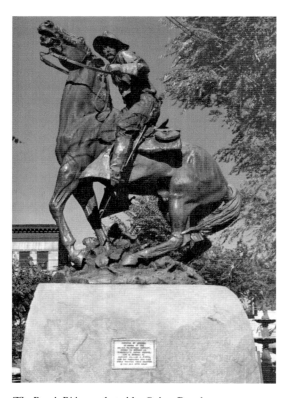

The Rough Rider, sculpted by Solon Borglum, was dedicated in Prescott on July 3, 1907. It's been called one of the world's best equestrian statues. *Courtesy of Southwest Studies Archives.*

Company A stared in shocked disbelief at the sight of their leader lying dead on the battlefield. He would be the only officer in the Rough Riders to die in battle.

At the courthouse plaza on July 1, 1907, a statue honoring the Rough Riders was dedicated in the plaza in downtown Prescott. Today, it's more familiarly known as the "Buckey O'Neill Statue" in honor of one of Arizona's greatest heroes. Created by the noted sculptor Solon Borglum, many regard it as one of the finest equestrian statues in the world.

Among the lawmen of the Old West, the colorful Irishman was one of the most brave and daring. His incredible feats made him a legend in his own lifetime. He died as he'd lived.

A few years earlier, in an article titled "A Horse of the Hash Knife Brand," he'd written:

The Indians were right. Death was the black horse that came some day [sic] into everyman's camp, and no matter when that day came a brave man should be booted and spurred and ready to ride him out.

2

JIM ROBERTS

THE PLEASANT VALLEY WAR'S TOP GUN

Sometime around eleven o'clock on the morning of June 21, 1928, Earl Nelson and Will Forrester drove into the smelter town of Clarkdale and parked on the main street outside the Bank of Arizona. The two men, bank robbers from Oklahoma, got out of the car and walked into the bank lobby. Nelson, the younger of the two, was carrying a parcel wrapped in a newspaper. He paused and waited by the door.

The gunmen had been living in Clarkdale a few weeks and had been casing the bank for the heist. They figured the best time to pull the job was around midday and at a time when the big Phelps Dodge payroll was in the vault. They also planned their escape carefully. In the car was a box of nails to toss into the road in case they were being pursued. They also had cayenne pepper and oil of peppermint to befuddle hound dogs if they had to abandon the car and head into the wild country on foot.

Clarkdale was a quiet company town, and a bank robbery in broad daylight was highly out of the ordinary. And that's what the outlaws were counting on. Inside the bank, a few customers were standing in front of the grilled windows of the tellers' cages. Others were filling out deposit or withdrawal slips at the counter.

Will Forrester walked past the customers and headed for the manager's office located next to the cages. When he was in a position to cover the room, he whipped out a pistol and shouted to bank employees Bob Southard, Marion Marston and Margaret Connor, "Step back here and no foolishness. The bank is being robbed."

Earl Nelson stepped from the lobby and pulled the newspaper wrapping from a sawed-off shotgun. "Just don't move, folks, and everything will be all right," he said grinning, "We won't keep you long."

While the customers looked on in shock, Forrester pulled a gunnysack from beneath his coat and gave it to the teller at the same time, motioning with his pistol for the employees to start filling it with money.

About that time, David Saunders, bank manager, returning from a trip to the post office, walked in to find his bank being robbed. Saunders was ordered to move over with the others. While Forrester turned his attention to the money stashed in the open vault, he slowly moved toward his desk. The robber saw Saunders's movement out of the corner of his eye and swung his pistol menacingly toward the manager, saying, "You turn in an alarm and I'll come back and kill you if it takes twenty years."

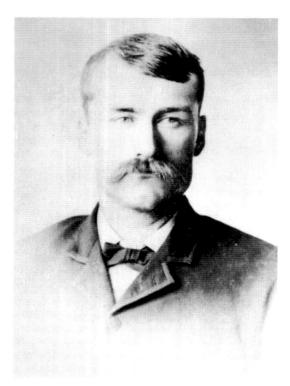

Jim Roberts was top gun for the Tewksbury faction in the Pleasant Valley War. After the feud subsided, he became a deputy sheriff in Yavapai and Cochise Counties. *Courtesy Southwest Studies Archives.*

The gunnysack was stuffed with cash, some $40,000. Forrester ordered the employees and customers into the vault, where they would be locked away while the two made their escape.

As the vault door was being closed, bank manager Saunders protested they would all suffocate in the vault he claimed was airtight. A mass murder would be added to their charge of bank robbery. Forrester reluctantly decided to lock them behind the outside grating door only. Before leaving, he issued a stern warning that anyone stepping outside the bank would be shot.

Once the robbers left the bank, Saunders began working on the grating lock.

Within moments, he had the door open. He grabbed a gun from beneath a teller's window and rushed into the street, firing into the air.

By this time, the two bandits were in their car and driving off. They had just rounded a corner about one hundred feet down the street. With all their careful planning, they hadn't reckoned on an old gunfighter from the days of yore happening on the scene.

Jim Roberts, a Yavapai County deputy sheriff and town constable, was making his rounds when he heard the commotion. By some curious twist of fate, he'd reversed his rounds that morning and just happened to be in the right place at the right time. Roberts was seventy years old and approaching the end of a long and illustrious career as a lawman and gunfighter.

Jim Roberts also was something of a disappointment to the hero-worshiping youngsters of 1920s Clarkdale. They'd learned all about the Old West watching Saturday afternoon matinees at the movie theater. They'd seen Tom Mix leap mighty canyons on his wonder horse, Tony. They knew real gunfighters like Mix, Buck Jones and Hoot Gibson packed two pistols in buscadero gun belts and wore fancy high-heeled boots, silver spurs, wide-brimmed hats and bright-colored, silk neckerchiefs.

One day, an adult explained to the kids that the old lawman had been a famous gunfighter in his day and was the best gunman in the Pleasant Valley War. Still, the youngsters were skeptical. "Uncle Jim," as they called the old-timer, wore eastern clothes and packed his pistol in his back pocket. He neither smoked, drank nor played cards, and the strongest cuss word he could muster was "dang." To add to their disillusionment, he preferred to ride a white mule instead of a long-legged stallion. He was friendly if you said hello, but start asking him questions about his illustrious past and he'd clam up tighter 'en a cigar-store wooden Indian. Like the rest of the feudists who really took part in the notorious Graham-Tewksbury Feud, Roberts was tight-lipped. Writers were coming around trying to get a scoop, and the only ones talking were those who didn't really play a major part or know what they were talking about. Men like Roberts knew that by talking, old wounds would fester and hard feelings would return. It was better to leave it lie. Silence was a characteristic common to feudists throughout the West.

Old-timers tell a story in Verde Valley about the time a movie company offered Roberts a substantial sum of money to be technical director of a film on the Pleasant Valley War. He stunned them by refusing to divulge what he knew. As a consolation, they asked if he would show them all how the old gunfighters drew and fired their six-guns. He obliged by reaching into his hip pocket and pulling out his nickel-plated Colt and, using both hands, took a

slow, deliberate aim. Expecting to see a lightning-fast draw, the movie people were disappointed. The youngsters, used to Tom Mix and the other shooting stars of Hollywood, were convinced he was a phony.

But what happened in the next few moments in Clarkdale would make true believers of a whole new generation. Uncle Jim was still a force to be reckoned with.

The old lawman saw a car gathering speed as it roared past him. His instincts told him the men in the automobile were up to no good. Then he saw the gun pointing at him.

From inside the speeding car, Nelson saw the old man with a badge pinned on his shirt and opened fire.

These two "eastern" bank robbers had no way of knowing the old man staring at them was the legendary Jim Roberts, one of the greatest gunfighters to ever pin on a badge. He certainly didn't look like a gunfighter. His eyes squinted as if he needed glasses. He was wearing a black eastern-style hat, and he wasn't wearing a gun belt.

The old lawman, ignoring the screaming bullets, drew a nickel-plated Colt .45 from his hip pocket and, holding the revolver with two hands, drew a bead on the driver of the speeding car. The pistol roared and bucked as flame shot from the muzzle. Forrester's head jerked backward as a bullet struck him. Another shot rang out, striking a tire. In an instant, the car skidded and then careened off the road and into the schoolyard, where it smashed into the guy wire of a telephone pole.

Will Forrester was dead at the wheel with a bullet wound in the neck. Nelson, his clothes bloodied from his partner's gunshot wound, jumped from the crash and ran into the schoolhouse. He momentarily considered making a stand but surrendered meekly when he saw the old lawman coming through the door with smoking six-gun in hand.

Earl Nelson was arraigned in Clarkdale before being turned over to Yavapai County sheriff George Ruffner and taken to Prescott. Inside the getaway car were two shotguns, two pistols, a rifle and a coil and fuse for setting off dynamite, as well as the keg of nails and cayenne powder. Nelson was only twenty-three but had a long criminal record in Oklahoma, where he'd been a member of an outlaw gang. For a time, Arizona lawmen kept him well guarded, fearing gang members from Oklahoma would try to spring him. He was eventually sentenced to thirty to forty years in the state penitentiary at Florence. In 1931, he escaped by hiding in the false bottom of a dump truck. He was later caught hiding out in Phoenix. One story has it he pulled another bank robbery and stashed the loot, some $40,000,

hiding it somewhere near Stoneman Lake. Another story has it he boasted to inmates at the state prison in Florence that he and Forrester had robbed a bank in Oklahoma and buried the money around the lake. Whichever version one chooses to believe, treasure hunters have searched in vain for the bandit's stash. It's still the subject of a Dean Cook song and several lost-treasure stories.

Old Jim Roberts was a whole lot more than those young whippersnappers bargained for. Men had underestimated him before. He was extremely tight-lipped about his past. One man had ridden with Roberts for years and never knew he'd been a key figure in the Pleasant Valley War until a writer told him. Jim had never mentioned it.

Back in the early 1970s, as a young historian, I had the pleasure of becoming acquainted with Roberts's son, Bill. Off and on for several weeks, he regaled me with stories about his father, but he had no luck trying to get him to talk about the Pleasant Valley War. He recalled that when the famous lawman came home for lunch after thwarting the Clarkdale bank robbery, his mother asked why he was later than usual, and he casually replied, "There was some trouble downtown." That was all he ever said about the gunfight.

Long before thwarting what was at the time the biggest heist in Arizona history, Jim Roberts had carved a niche for himself in the lore of great gunfighters and lawmen. He was considered the top gun in the Pleasant Valley War. He wasn't like some of those young hellions who rode into the valley looking to start "a little war of our own"; Roberts was a quiet man who settled there to raise horses. He was reluctantly drawn into the conflict when some of the Graham faction stole his horses and burned his cabin.

Jim Roberts was born in Bevier, Macon County, Missouri, in 1858. He arrived in Arizona when he was eighteen. Little is known about the early years of his life. His son, Bill, once told the author that his mother only knew that he was "from Missouri." During the mid-1880s, he arrived in Pleasant Valley and settled near the headwaters of Tonto Creek at the foot of the Mogollon Rim. One day, a team of horses turned up missing, and Roberts tracked them to a camp of Graham supporters. He inquired if anyone had seen his horses, and the boys made some flippant remarks about their whereabouts, which confirmed his suspicions. As Roberts started to ride away, one of them remarked, "That's a damn fine horse he is riding, and when he stops tonight we'll get him too."

Another version—and there are as many versions of this feud as there are storytellers—had Roberts tracking down three horse thieves and killing

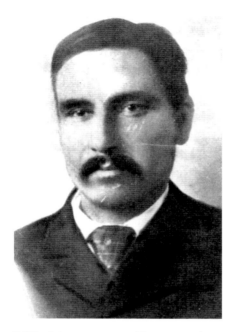

Ed Tewksbury, an expert rifleman, was the leader of his faction in the famous Graham-Tewksbury Pleasant Valley War. *Courtesy of Southwest Studies Archives.*

them all in a shootout. Jim Roberts was what was known in the Old West as a "man with bark on."

They never got his horse, but they had incurred the wrath of the man who would prove to be the most deadly gunman among the Tewksbury faction. How many men he personally accounted for in the war is open to conjecture. Roberts didn't discuss those matters, even with members of his family.

Jim Roberts had been friendly with the Tewksbury boys since moving into Pleasant Valley, and after the horse-thieving incident, he joined the clan in the war with the Grahams.

The Graham-Tewksbury war had its beginnings around 1880, when Jim Stinson moved a large herd of cattle into remote Pleasant Valley. The valley was nestled beneath the Mogollon Rim, 75 miles northeast of Globe and a three-day trip by wagon. The railroad town of Holbrook was 100 miles north of the valley. The county seat at Prescott was 150 miles to the west over rough terrain. Both Payson and Flagstaff were small settlements at the time.

James Dunning Tewksbury and his family moved from California into the valley in 1879. His Hupa/Hoopa Indian wife and the mother of his

Tom Graham, leader of the Graham gang. Don't let his calm, preacher-like appearance fool you. He was a deadly killer. *Courtesy of Southwest Studies Archives.*

boys, John, Ed, Jim and Frank, had died in California. In late 1879, the senior Tewksbury married a widow named Lydia Schultes of Globe. Despite having grown children from previous marriages, J.D. and Lydia had two more children of their own, becoming one of those "his, hers and ours" families. One of Lydia's daughters, Mary Ann, married J.D.'s oldest son, John. The Tewksburys settled on ranches on the east side of Cherry Creek.

The Graham brothers, Tom, John and Billy, arrived in the valley from Ohio in 1882, ironically at the invitation of Ed Tewksbury. The two families got along well at first. They settled on the west side of the Cherry Creek. In the annals of the West, most feudists waged war from ranches located at least several miles apart. The Graham-Tewksbury war was unusual in that the ranches were within eyesight of each other.

Jim Stinson branded his cattle with a simple "T," an invitation to alter if there ever was one. Soon there were a dozen or so brands stamped on cows' hides that were all various alterations of the "T," including the famous "Hash Knife" up on the Mogollon Rim.

In January 1883, John Gilliland, foreman for Stinson, rode over to the Tewksbury ranch and accused them of stealing his boss's cattle. Tom and John Graham were visiting the Tewksburys at the time. Gilliland was accompanied by his fifteen-year-old nephew, Elisha, and a vaquero named "Potash" Ruiz.

Ed Tewksbury stepped out and said, "Good morning, boys, who are you looking for?"

Gilliland jerked his six-gun and replied, "You, you son of a bitch." His shot missed. Tewksbury grabbed a .22 rifle and returned the fire, hitting both Gilliland and Elisha. The youngster fell to the ground as Gilliland and Potash rode away. Both wounds were minor, however, in July, Gilliland filed murder charges against the Tewksburys.

The Tewksburys were ordered to ride 150 miles to Prescott to answer charges. A judge dismissed the case as frivolous, but on the ride home, a weakened Frank Tewksbury took sick and died. The enraged Tewksbury brothers blamed Frank's death on Stinson and Gilliland.

It's believed that sometime during the trial, Stinson cut a deal with the Grahams in which they would secretly work for him as range detectives, for a price. This classic double-cross would certainly be cause for the Tewksburys to transfer their vengeful feelings to the Grahams and their friends.

On March 29, 1884, John Graham did in fact file a felony complaint against the Tewksbury brothers for altering brands on sixty-two head of cattle. At the trial in Prescott, the defendants were all found innocent, and perjury charges were leveled against the Grahams.

Was cattle rustling the root of the feud? Probably. A lot of ranches got their start with a long rope and a running iron, and Stinson's cattle were easy pickings. It's been claimed the feud started over sheep being driven off the rim onto the cattle ranges, but that came later. It's also been claimed the feud started over a woman, but that seems unlikely.

During the next eighteen months, the tension mounted. The Tewksburys were running short of money defending themselves from trumped-up charges, and Stinson was losing both cattle and money trying to protect his interests. As far as the Tewksburys were concerned, Stinson was using his power and money to run them out of business.

On July 22, 1884, John Tewksbury and George Blaine rode into the Stinson ranch and, after a heated exchange, engaged in a brief gunfight. Both suffered wounds at the hands of Stinson's men. After a brief inquiry, no charges were pressed, and the matter was officially dropped.

At some point during that time, John Tewksbury had whipped John Graham in a fistfight. Things were certainly heating up.

Mart Blevins and his family arrived from Texas around 1886. He and his sons—John, Charley and Hamp Blevins and Sam Houston—took over a ranch mob-style on Canyon Creek and hooked up with the Graham faction. Another of Mart's boys, Andy Blevins, using the alias Andy Cooper, had arrived from Texas two years earlier. He'd already gained a reputation as a badman in Texas. Anticipating action, more ruffians descended on the valley.

More fuel was thrown on the fire in February 1887, when Bill Jacobs, a friend of the Tewksburys, drove a flock of sheep into Pleasant Valley. It didn't take cattlemen long to retaliate. A sheepherder was killed, his body riddled with bullets and, according to some accounts, beheaded.

In July, Mart Blevins rode off from the Canyon Creek ranch on the trail of some horse thieves and was never seen again. A few days later, Hamp Blevins, along with four Hash Knife cowboys—John Paine, Tom Tucker, Bob Carrington and Bob Glaspie—were out searching for Hamp's father. They met cowhand Will C. Barnes at Dry Lake, about thirty miles south of Holbrook, and mentioned they were headed for Pleasant Valley to "start a little war of our own."

On the ninth of August, they arrived at the Newton (old Middleton) Ranch, located on Wilson Creek at the eastern part of Pleasant Valley. The ranch was the scene of a battle with Apaches a few years earlier and had been abandoned by the Middleton family and was now occupied by George Wilson. Inside, Jim Roberts, Joe Boyer and Jim and Ed Tewksbury were

sitting down to dinner when the riders approached. The boys, still sitting on their horses, asked to be invited in for a meal.

"We aren't keeping a boarding house," Jim Tewksbury told them, "especially for the likes of you."

John Paine had a reputation as a bad hombre with a real mean streak who loved to fight. He'd been hired by a big outfit to beat up on small ranchers and shipmen in the area and enjoyed it. Tom Tucker was mostly looking for adventure. Glaspie was more stupid than mean and was easily led by killers like Paine. Not much is known about Bob Carrington.

Hamp Blevins drew his pistol and started firing, drawing a fusillade of fire from inside the cabin. The first volley of gunfire, Jim Roberts dropped Paine with a shot between the eyes. Another shot tore off the top of Blevins's head. Both toppled to the ground with fatal wounds. Then Tucker went down with a bullet in the chest. Bob Glaspie took a bullet in the right leg. Carrington's clothes were perforated, but he managed to escape unhit. None of the Tewksburys were hurt. It's likely the Tewksburys and Roberts were using the latest rapid-firing Winchester Model 1886 .45-90 rifles. As one old-timer put it, "It was like shooting a cannon."

Tucker, badly wounded, managed to ride away but later fell from his saddle. Along the way, he was attacked by a mama bear and her two cubs. By the time he reached a ranch, the chest wound was covered with maggots, and that probably saved his life, as maggots eat only dead flesh, thus preventing gangrene from setting in.

Glaspie was wounded in the leg, the bullet passing through the cantle of his saddle and exiting through his buttocks. During the fight, his horse was also shot out from under him. He managed to make his way on foot back to the Blevins ranch on Canyon Creek three days later.

The nefarious little war party off to start a little war of their own was fully routed.

Immediately following the battle, the defenders inside the cabin saw another large party approaching. They quickly made ready for another siege. When the riders were close enough, Roberts saw they were Apache, armed and painted for war. But when they saw the carnage, one of them shouted "*chinde,*" an Apache word for ghosts. Fearing the presence of evil, or the deadly aim of the shooters inside, they quickly turned tail and rode off.

Jim Roberts and the Tewksburys decided not to press their luck any further, and they, too, rode off.

That evening, members of the Graham faction returned to bury the bodies and before leaving burned the cabin to the ground.

The Tewksbury cabin in Pleasant Valley. Note the bullet holes in the walls. *Courtesy Southwest Studies Archives.*

Following the shootout, John Blevins had some second thoughts about security at the ranch on Canyon Creek. The ranch had been a lair for horse thieves, but with the killing of his brother Hamp and mysterious disappearance of his father, Mart Blevins, he decided to relocate the family to a little cottage in Holbrook until things cooled off a bit. Ironically, it was less than a month later that Apache County sheriff Commodore Perry Owens went to the house to arrest one of the Blevinses. In the ensuing gun battle, two more Blevins brothers would die, and John would be seriously wounded.

On September 2, 1887, Jim Roberts, along with several members of the Tewksbury family, were at the Lower Tewksbury Ranch on Cherry Creek (both the Tewksburys and Grahams had three ranches in the valley) when some twenty Graham partisans, led by Andy Cooper Blevins, attacked the ranch. Among them were Tom and John Graham, Mote Roberts (not related to Jim) and Charlie and John Blevins. Some accounts claim future governor George W.P. Hunt was among the gang.

Historians disagree on who was inside the solid-walled cabin that day. One version has it Ed Tewksbury and John Rhodes were there, while J.D. was

in Prescott. Another says J.D. and Lydia were in Phoenix. Still another has Ed and Jim with Jim Roberts at their "mountain hideaway," eluding warrants for their arrests, while John Rhodes was at the Tewksbury headquarters.

Others inside the cabin included John Tewksbury's pregnant wife, Mary Ann; J.D.'s wife, Lydia; her twelve-year-old son; and their two youngsters, ages three and six.

The Graham partisans positioned themselves on the opposite side of Cherry Creek in the brush and waited. After breakfast John Tewksbury and Bill Jacobs headed out to wrangle the horses. Several shots rang out, and the two men fell to the ground, shot from behind. One of the shooters walked up to Tewksbury, fired three more shots into him and then picked up a huge rock and smashed his head.

The attackers kept firing into the cabin throughout the day. They paused long enough to announce that John Tewksbury and Jacobs were dead, but they wouldn't allow the Tewksbury men to see them. Apparently they did allow Lydia, her young son and possibly Mary Ann to look at the bodies.

Mary Ann Tewksbury would later claim she begged Tom Graham to let her bury her husband and Jacobs, but he refused.

Apparently the Graham partisans believed the Tewksburys had gunned down Old Man Blevins and then allowed the wild hogs to eat him, for Tom Graham replied, "No, the hogs have got to eat them."

It was claimed that Andy Cooper Blevins wanted to scalp Tewksbury, but Tom Graham forbade it. Graham knew if one side started taking scalps, the other would respond in kind.

Cooper also wanted to burn the cabin but, because of the women and children inside, was again forbidden by the others.

During the fight, John Rhodes slipped away, evading the snipers, and headed to the mountain hideaway to alert Jim Roberts, Joe Boyer and Jim Tewksbury. Roberts then rode hard to Payson to summon Justice John Meadows and a posse.

Rhodes, Tewksbury and Boyer rushed back to the siege but were driven back by withering rifle fire from the Graham partisans. They managed to gain a position atop a nearby hill, where they could return fire and support Ed, who was firing from inside the cabin.

Help didn't arrive for eleven days. Snipers hung around for several days, firing at anyone who tried to leave the cabin. The men foraged for wood and brought in water at night.

Some versions say Mary Ann defied the snipers, who peppered her feet with rifle shots during the day, by creeping out at night and, since the ground

was too rocky to dig graves, covering the bodies with bed sheets anchored with rocks to keep the hogs from devouring the bodies.

By the time the posse arrived, the snipers had left, and what was left of the bodies of the two slain men was placed in an Arbuckle Coffee crate and buried in a single grave.

Mary Ann gave birth to her baby boy ten days after the fight and named him John after her late husband. She later married John Rhodes, and the boy, who took his stepfather's last name, became a rodeo cowboy, winning World Champion Roper in 1936 and 1938.

The Tewksburys were understandably bitter. Later, Jim Tewksbury would say contemptuously, "No damned man can kill a brother of mine and stand guard over him for the hogs to eat him and live within a mile and a half of me."

Two weeks after the bushwhacking of John Tewksbury and Bill Jacobs, the Grahams staged another daring ambush on Jim and Ed Tewksbury, the remaining brothers, and Jim Roberts while they were camped at Rock Springs on Canyon Creek. On the morning of August 17, Graham partisans crept up before dawn and positioned themselves to attack on horseback at first light. They were expecting to catch the Tewksburys and Roberts sleeping, but it was not to be. Roberts had gotten up early and gone out to gather the horses. He saw the Grahams approaching and rushed back to warn the others, who grabbed their rifles and opened fire. All of them crack shots, Roberts and the Tewksburys poured deadly accurate fire, emptying the saddles of several Graham partisans. Harry Middleton took a bullet and died a few days later at the Graham ranch. Joe Ellingwood was sniping away from behind a tree, his leg exposed. Roberts drew a bead on the leg and put a bullet through his calf. Another unwisely made a taunting gesture by rubbing his butt. A shot rang out, and the man "jumped ten feet" with a bullet in the rump.

After a while, Tom Graham called for a truce to remove the dead and wounded. Unlike the previous battle at the Middleton cabin, where Graham partisans kept the Tewksbury faction pinned down for eleven days while semi-wild hogs feasted on the bodies of John Tewksbury and Bill Jacobs, the Tewksburys graciously allowed the Grahams to bury their dead and carry off their wounded. The Tewksburys and Roberts watched soberly as the Grahams tossed the bodies of the dead into a crevasse and threw rocks and dirt on top. The dead were transient gunmen hired by Tom Graham, and their names remain unknown. Perhaps Graham didn't even know their names.

The Pleasant Valley War was making national news by now, and lawmen from the county seat at Prescott were moving through the area trying to arrest members of both factions. Yavapai sheriff Billy Mulvenon and his posse of some twenty men rode toward Young again.

The sheriff was still smarting from an earlier visit. While he and his men were meeting with Graham partisans to arrange a truce between the opposing parties, someone stole all their horses. This time the sheriff meant business. The Perkins Store in Young was about a mile south of the Graham ranch. Mulvenon posted his men behind the four-foot-high rock wall at the store and dispatched riders to circle around the valley to attract attention. Signal shots were fired from the Graham house and by a partisan, Al Rose. Strangers in the valley were always cause for curiosity, and Charley Blevins and John Graham rode cautiously down toward the store to check out the strangers. When they were near enough to see the danger, they spurred their horses and headed toward an arroyo north of the store. Lawmen opened fire and emptied their saddles. They also arrested two others, Al Rose and Miguel Apodaca. Rose talked tough, saying, "If you want anything here come and get it." But when he saw the number of guns pointed at him, he meekly surrendered. Tom Graham, the leader, was able to escape the posses of both Sheriff Mulvenon and Commodore Perry Owens and made his way to Phoenix.

Following those arrests, the posse rode into the lair of the Tewksburys. Their surrender had been prearranged; the Tewksburys and Roberts had said they'd come in peaceably once the Grahams were corralled, and they did. Later, when it was learned Tom Graham had gotten away, the Tewksburys were livid.

The fighting men from both sides were taken to Payson to appear before Justice of the Peace John Meadows, and all were released for lack of evidence except Roberts, Joe Boyer and the Tewksbury brothers. They were held over for a grand jury in Prescott for the shootings at the Newton ranch. Bond was posted, and they all returned to Pleasant Valley and tried to pick up the pieces of their lives. Although Jim Roberts was indicted for murder in the range war, prosecutors eventually dropped all charges.

Al Rose would later be hanged by vigilantes.

The price in blood had been heavy for both sides, especially for the Blevins, Graham and Tewksbury families. John Blevins, wounded at Holbrook, was the sole survivor of the fighting men in his family. His father, Mart, along with brothers Andy, Hamp, Charley and Sam were all killed during the feuding. Tom Graham was the sole survivor of his family, losing his two brothers, Billy and John.

Ed was the last of the fighting Tewksburys. Frank died of pneumonia in 1883. In a weakened condition, he'd been forced to ride 150 miles in bad weather to Prescott to answer some trumped-up charges by the Grahams. On the way home he got sick and died. John was killed during the war, and Jim would die of consumption in December 1888.

The "war proper," as they called it, was over; however, assassinations and lynchings would continue for quite some time.

It's been said fifty-four people disappeared and twenty-eight were known killed in the feud. The vigilance committee, calling itself the "Committee of Fifty," actually numbered far fewer. Silas Young and Colonel Jesse Ellison were the leaders of this phantom group. They spoke of restoring order, but there's hard evidence the self-righteous pair saw an opportunity for a land grab. Young and Ellison each wanted it all but eventually agreed to a split. Silas Young took over the Graham ranch, and Ellison claimed the Tewksbury ranchlands on the east side of the creek.

In the aftermath, Tom Graham got married and settled down in Tempe. But feuds and bad blood don't die easy. On Tuesday morning, August 2, 1892, he was driving a wagonload of grain on Double Buttes Road leading into town. Beside the road, Ed Tewksbury and his brother-in-law John Rhodes sat waiting in ambush. As the wagon passed, Tewksbury raised his weapon, a .45-90 Winchester rifle, and shot Graham in the back. He slumped back on the sacks of grain, mortally wounded. He lived long enough to name his assassins. Tewksbury made a hasty escape by picketing a relay of fast, durable horses from Tempe to the Tonto Basin. To establish his alibi, Ed Tewksbury had to ride 170 miles in less than a day.

Ed Tewksbury, proclaiming his innocence, surrendered. Fearing a lynching, lawman Henry Garfias met Ed at the Kyrene railroad station and they rode quietly into Phoenix, where he was booked in the county jail.

Ed Tewksbury continued to deny any involvement, claiming he was in the Tonto Basin at the time. Actually, he'd picketed some fine horses along the way and made a record-setting endurance ride to establish his alibi.

John Rhodes was tried first, and his trial turned out to be quite a sensation. Anne Melton Graham, Tom's widow, slipped a pistol into the courtroom in her purse and attempted to shoot Rhodes, but the weapon failed to fire.

Rhodes had an alibi—he claimed to be somewhere else, and the court believed him. He later became an Arizona Ranger.

Ed Tewksbury's lawyers used delaying tactics to postpone his trial for some sixteen months after the murder of Tom Graham. His alibi of being in the

Tonto Basin the day of the shooting was doused when a witness testified to seeing Ed drinking in a Tempe saloon that same day.

Then his lawyers got a change of venue and moved the trial to Tucson. The argument came down to whether or not Tewksbury could have ridden from Pleasant Valley to Tempe and back in a day.

The jury returned a guilty verdict, but Ed's lawyers went on the offense, arguing, on legal technicalities, that Ed hadn't appeared in person for his plea of abatement, and he was given a new trial.

Richard E. Sloan, future territorial governor of Arizona, was the judge at the new trial. This time, Ed's lawyers planted a seed of doubt in the eyes of the jury, and the result was a hung jury. After two and a half years behind bars, Ed was free on bond. By now, too much time had passed, and the prosecution, believing it could not get a conviction, dismissed all charges. Ed Tewksbury was a free man. He sold his holdings in Pleasant Valley and moved to Globe, where he became a well-respected deputy sheriff. He died in 1904 of consumption. Ed Tewksbury would be the inspiration for Zane Grey's classic novel of the feud, *To the Last Man*.

In reality, Jim Roberts was the last man.

Jim Roberts's days as a warrior in the Graham-Tewksbury Feud were over. For the next forty-four years, he would wear a badge and keep the peace. And there was no better lawman in Arizona when it came to taming tough towns. In 1889, the new Yavapai County sheriff, Buckey O'Neill, appointed him deputy and assigned him to the mining town of Congress in the southern part of the county. Romance came into the life of the handsome lawman at Congress. There he met Permelia Kirkland, pretty daughter of the renowned rancher-pioneer William Kirkland. At the time, Kirkland was justice of the peace at Congress.

Kirkland was a man of many firsts in Arizona. He'd been the first Euro-American to engage in ranching in Arizona; he raised the first American flag over Arizona following the Gadsden Purchase; he and his wife, Missouri Ann, were the first Euro-American couple to marry in Arizona; and they were the parents of the first Euro-American child born in Arizona. His third child, Ella, born in 1871, was the first Euro-American child born in Phoenix.

Jim Roberts met the lovely Melia Kirkland at a dance in Congress. She was the belle of the town, and he asked her to dance. Afterward, he gave her a piece of candy. Although the pretty twenty-year-old blond was engaged to someone else at the time, Roberts came courting two days later. She later said of her intended, "He was a nice boy, but Jim was a real man." On

November 17, 1891, they were married in Prescott. They would eventually have a family of three sons and two daughters.

Following the wedding, he and Melia moved to the rough-and-ready town of Jerome. Jim had proven to be a capable lawman, and the new sheriff, Jim Lowery, figured him up to the task to tame the mining camp on the slopes of Cleopatra Hill.

Payday came only once a month, but it was Katy-bar-the-door. Saloons, gambling halls and bordellos were open twenty-four hours a day to accommodate the lusty miners. It was said the shutters on the buildings were extra thick to keep the inside shootings in and the outside shootings out. The local jail wasn't large enough to hold all the arrests, so Roberts handcuffed prisoners to wagon wheels, hitching posts and anything else that was strong enough to hold them.

Jerome had its share of desperados. One time Roberts went after an outlaw on his mule, Jack. He preferred the sure-footed animals on the dangerous mountain slopes. The man had boasted he wouldn't be taken alive, so the lawman led a little burro to haul the corpse back. Sure enough, that's how they returned.

One old-timer from Jerome told of his own baptism of fire while working as a young deputy with Roberts. Three men had gotten into a fight in a gambling hall and had committed a murder. They holed up on the outskirts of town and challenged Roberts to come and get them. As the lawmen approached the three killers, Roberts said quietly to the young deputy, "You take the one in the middle, and I'll get the front one and the other one."

He glanced at the youngster out of the corner of his eye and saw his gun hand was shaking badly. "Never mind, son," he said kindly, "I'll take 'em all." And he proceeded to gun down all three.

"Jim never did say much," said one old-timer, "and when he was mad, he said nothing at all."

One of his best-known pursuits and capture of desperadoes came when Sid Chew and Dud Crocker murdered his deputy Joe Hawkins.

It began one evening in a vacant lot down the street from the Fashion Saloon. Crocker was handcuffed to a wagon wheel. He'd started a fight in a saloon earlier and been pistol-whipped into submission by Hawkins. The sullen Crocker determined to get even by killing the deputy when he got loose.

After dark, when things quieted down, his partner Sid Chew crept up, took a wrench from the toolbox on the wagon and removed the axel nut from the wagon wheel. Chew pulled the wheel from the spindle, and the two picked up the wheel and hauled it down the street to the blacksmith shop.

The streets were quiet; most of the noise was coming from the saloons. No one noticed as Chew pried open the swinging doors with a pinch bar. He lit a coal oil lantern and heard a voice from the rear of the shop where the blacksmith's helper bunked. "Who's there?" he asked.

"Come give us a hand," Chew called back.

When the helper walked in, Chew hit him with a roundhouse punch to the jaw. The helper stumbled backward, fell and split his head open on an anvil.

Chew hurriedly picked up a chisel and hammer and cut the handcuffs from the wheel. In a moment, Crocker was free of his bonds. They doused the lantern and headed back to the little room at a boardinghouse they shared. Each man armed himself with a pistol.

A few minutes later, a commotion down the street told them Crocker's escape had been discovered. Deputy Hawkins knew where Crocker lived, and he wasted no time getting to the boardinghouse. As he approached, they opened fire, hitting the deputy several times. Before going down, Hawkins got off a shot, hitting Chew in the leg.

The rampage of Chew and Crocker that evening had taken two lives.

By the time Jim Roberts had been summoned, the two killers had taken two horses at gunpoint from a livery stable and ridden into the night.

Roberts climbed on his trusty mule and, leading a pack burro, headed down the mountain toward the Verde River. His years in the Pleasant Valley War had taught him all the finer points of tracking, and his experience as a lawman had taught him how to think like a fugitive. He figured correctly the two would get into the river to cover their trail and head downstream toward Camp Verde. He also figured they'd hole up during daylight near a hill where they could look back to see if they were being followed.

The lawman rode into Camp Verde and learned that no riders had passed that way, so he headed back up the river until he came to a commanding hill. He climbed to the top, being careful to keep some chaparral between him and the river. Sure enough, when he got to the top he could see a wisp of smoke coming from a thick monte by the river.

He slipped quietly down to the river and crept up to where he could see two men shivering beside a small campfire.

He called out to the men, "No need shootin'. Just drop your guns. Don't draw."

The two murderers jumped away from the fire, grabbed their six-guns and fired in the direction of the voice. Roberts's first shot dropped Crocker with a bullet to the head. Chew charged, firing wildly. Roberts's next shot drove him backward to the ground.

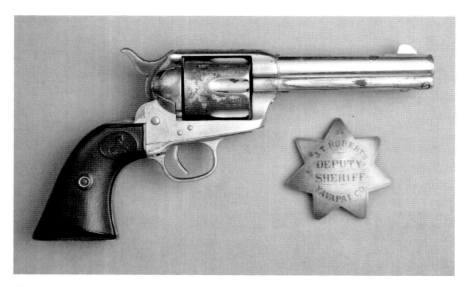

The Colt revolver and Yavapai County badge worn by Jim Roberts. *Courtesy of Southwest Studies Archives.*

Later that day, the quiet lawman rode into Jerome with the bodies of Chew and Crocker tied across his pack animal and delivered them to the undertaker.

On December 8, 1892, he was elected constable of the Jerome district and served that office for the next eleven years. In April 1904, he was elected town marshal of Jerome.

Tragedy struck the Roberts family in 1902, when three of their four children died during an epidemic of scarlet fever in Jerome. First to die was five-year-old Jim Jr., who died less than forty-eight hours after coming down with the fever. Three days later, Nellie died. Two weeks later, they lost nine-month-old Myrtle. His wife, Melia, and nine-year-old Hugh both contracted the disease but recovered. A fifth child, Bill, was born after the epidemic.

Jim Roberts was a devoted family man and was deeply hurt by the loss of his children. A quiet man by nature, it was said he became even more withdrawn after burying his children. A story is told he'd promised to buy little Nellie a rocking chair, but she died before he could, so after the funeral, he brought home a small rocker in remembrance.

Leaving Jerome, he took a job as deputy sheriff in Cochise County. During the next few years, he worked as a peace officer in Florence and Humboldt.

The tragic death of his children in Jerome had left such a painful memory that he vowed never to return to the mining town nestled on the slopes of Cleopatra Hill. But time helped heal the wounds, and in 1927, at age sixty-nine, he took the job as special officer for the United Verde Copper Company with a deputy's commission from Yavapai County and was stationed at Clarkdale.

True to his nature, after the gunfight with Nelson and Forrester, the old lawman finished his rounds and headed home for lunch. His wife later recalled how she was concerned because he was late, and the biscuits had gotten cold. He apologized, saying "he'd had a little trouble downtown" and quietly finished his meal without saying anything more about the gunfight.

Jim Roberts died while making his rounds on the evening of January 8, 1934. He suffered a heart attack and collapsed. Somebody found him and called an ambulance, and Uncle Jim died on the way to the hospital—with his shoes on. That was another thing: Jim Roberts didn't wear boots.

3
THE VANISHING TRAIN ROBBERS

On the evening of April 27, 1887, southern Arizona's only passenger train, the Sunset Express, was making its run toward Tucson. The train was running a few minutes behind schedule, so the engineer, "Colonel" Bill Harper, gave it a little more steam to make up time. About twenty miles east of Tucson at Cienega Canyon, the yellow streak from the headlight picked up a figure standing on the track waving a red lantern. About that time, the big drive wheels ran over a torpedo. The bomb-like sound served as a warning of trouble farther up the line. Colonel Harper slammed on the brakes and stopped just before crashing into some upraised railroad ties jammed between the tracks.

Suddenly, out of the darkness, rifle shots cracked, and several holes appeared in the engine's boiler. Two masked men stepped out of the darkness and ordered the engineer to step down off the train. They took him back to the express car and told him to have the Wells Fargo express messenger open the safe and then unlock the door and get out.

"Or what?" the stubborn engineer asked.

"Or we blow it up," one of the bandits replied, holding up a stick of dynamite.

Inside the express car, messenger Charlie Smith heard the conversation and opened the safe, took out some $5,000 and stuffed it in the cold, potbellied stove. The money safely hidden, Smith unlocked the door and jumped out.

The robbers, members of the infamous J.M. "Doc" Smart gang, climbed into the express car and found only a few scattered bills in the safe.

Disappointed, they gathered up the meager haul. Meanwhile, Harper was escorted back to cut the passenger cars from the mail and express car and then ordered to move the engine and the two cars ahead a few yards.

After receiving a few hurried instructions from Harper on how to run a locomotive, they told him to get the engine rolling and then ordered him to jump off. The engine, mail and express cars chuffed off toward Tucson with the outlaws on board.

Later that night when the Sunset Express failed to show, a relief train was sent out from Tucson. About fifteen miles east of the Old Pueblo, they discovered the abandoned engine and the ransacked express car. A few miles farther down the track, they found the anxious crew waiting by the passenger cars.

The next day, a posse led by Tohono O'odham Indian trackers went to where the engine was found and attempted to pick up the trail of the desperadoes. They circled farther and farther away from the engine in a futile attempt to cut the trail. It was as if the entire gang levitated into space.

Though a clever escape, the outlaws had been hoodwinked by Charlie Smith, the Wells Fargo messenger, who'd hidden the loot in the stove. The newspapers made a big deal out of it, and Smith became a local celebrity.

On August 10, the gang struck again. Same location, same train and the same Wells Fargo messenger—Charlie Smith. This time the engineer couldn't stop in time, causing the engine to jump the tracks and flip over on its side on the edge of a steep embankment. Out in the darkness, the outlaws opened fire. One bullet passed so close under the nose of fireman R.T. Bradford it burned off part of his mustache. The engineer, Jim Guthrie, hopped out of the prostrate locomotive and tumbled over the steep bluff, landing several feet below in the top of a mesquite tree.

Doc Smart and his boys weren't taking any chances this time. When Smith refused to open the door, the blast from a stick of dynamite shattered the door. Inside, their nemesis was slightly shaken from the blast.

One of the robbers pointed the business end of his six-shooter at poor Charlie and muttered, "Smitty, that stove racket don't go this time." No doubt the outlaws had heard the stories extolling how Charlie had outwitted them in the previous robbery.

A posse picked up their trail this time and followed it into the Rincon Mountains, where they came upon an abandoned sack containing $1,000 in Mexican silver. Nearby was a small cave the outlaws had used as a hideout prior to the robbery. They found several items the bandits had left behind, including a few coins, clothing, food and jewelry. The trail led to a larger cave

called Five-Mile Cave at Mountain Springs. Today that cave is a popular tourist attraction known as Colossal Cave. Luckily for the outlaws, a heavy rainstorm blew in and wiped out their tracks.

The gang got away clean that time with $3,000 in their pockets, and while lawmen scoured the Arizona Territory, the outlaws were living it up in El Paso.

Things had gone so well on the second robbery that two of the boys, Kid Smith and Dick Meyers, decided to rob the Southern Pacific Railroad again. The third time wasn't a charm.

On October 17, 1887, outside El Paso, they stopped the eastbound passenger train, headed straight to the express car and blew open the door. While the bandits were breaking down the door, messenger J. Ernest Smith had blown out the lamp. He laid his pistol on the floor, jumped from the open door and found himself staring at two gunmen who had the drop on him. He offered to climb back in and light the lamp, but instead, he reached in, grabbed his six-shooter and shot Kid Smith (no relation) in the heart. Meyers grabbed his partner and drug him away, and during the chaos, messenger Smith fired again, fatally wounding Meyers.

Smart detective work enabled lawmen in El Paso to locate the boardinghouse where the two outlaws had been staying. Soon they rounded up the rest of the gang, including Doc Smart.

Doc was tried and given a life sentence for his part in the robberies. While awaiting trial, somebody slipped him a pistol, but instead of trying to break out, Doc decided to take his own life. He put the pistol to his head and fired three shots, but the soft lead collided with his hard head, and all he got out it was a bad headache. Doc was eventually pardoned by President Benjamin Harrison

It wasn't until after the gang was in jail that lawmen were finally able to clear up the mystery of how they'd managed to vanish into thin air in the desert south of Tucson. One of the gang spilled the beans, and it was really quite simple. They'd ridden the engine into the outskirts of Tucson, put it in reverse, then jumped off and walked into town. The engine, with its perforated belly leaking steam, backed down the tracks some ten miles, where it was found—with no telltale tracks to follow.

Thanks to an accomplice who worked for the railroad, Doc and the boys left Tucson riding comfortably in an SP caboose back to El Paso.

4

COMMODORE PERRY OWENS

BRINGING LAW AND ORDER TO APACHE COUNTY

When old-time shooters, sitting around Gunfighter Valhalla, that mythical hall into which the souls of warriors are received, get to reminiscing about the great gunfighters of the Old West, Apache County sheriff Commodore Perry Owens is certain to be mentioned. Although Owens isn't exactly a household name in the West, and the roaring cow town of Holbrook, where he made his mark, isn't as well known as Tombstone, Dodge City or Abilene, Owens's spectacular shootout with members of the Blevins family is unsurpassed in the annals of the Old West.

Apache County historian Jo Baeza wrote:

> *From the beginnings of language to the present, there have been certain prerequisites to becoming a folk hero. They have little to do with morals, as mores change from epoch to epoch, people to people. More important in folklore are the timeless virtues of courage, honesty, physical strength, skill with a weapon and a conflict that the hero single-handedly resolves. Remember all these things as you read about Commodore Perry Owens.*

Commodore Perry Owens was born on July 29, 1852, on a small farm in eastern Tennessee. Contrary to popular belief, he was not born on the anniversary of Oliver Hazzard Perry's great naval victory over the British on September 10, 1813, at the Battle of Lake Erie. His father was named Oliver H. Perry Owens in Commodore Perry's honor, and his mother gave him the name.

Owens drifted down to Texas in the early 1870s and then on to Indian Territory, where he took a job on the Hilliard Rogers ranch near today's Bartlesville. Over the next few years, he worked as a cowhand driving cattle from Texas to the cow towns of Kansas. He also worked as a buffalo hunter for the Atlantic and Pacific in Kansas, honing his skills as an expert shot.

He arrived in Holbrook in 1881, about the same time as the Atlantic and Pacific Railroad. Soon after his arrival, he took a job guarding the stage station at Navajo Springs from horse thieves who preyed on the area. He had several brushes with local Navajos over disputed stock, and it was said they came to view him as an invisible ghost because their bullets never seemed to hit, while his "magic" guns never missed. Owens's experience as a buffalo hunter on the Kansas plains had turned him into an expert marksman.

Owens homesteaded at the Z Bar ranch some ten miles south of the springs where he raised purebred horses. The place became known as Commodore Springs.

Owens was described as a simple, charismatic man of few words, and when he did speak, it was with a slow drawl. He was a handsome man, standing five feet, ten inches, with light blue eyes and a slight, sinewy frame. According to old-timers, he cut a romantic swath on his fine sorrel horse with the pretty ladies around Concho and St. Johns.

Owens also had a reputation for integrity. One newspaper was quoted as reporting, "Mr. Owens is a quiet, unassuming man, strictly honorable and upright in his dealings with all men and is immensely popular." He took few men into his confidence and had few intimate friends.

One of the Old West's most famous gunfights occurred in Holbrook in 1887 between Apache County sheriff Commodore Perry Owens and members of the Blevins family. *Courtesy of Southwest Studies Archives.*

An early acquaintance described him as "kind and courteous, but very quiet, a perfect gentleman." Another said he was the most superstitious man he'd ever known. A man of action, not given to introspection, he was extremely cool under pressure—the type oft described as a "good man to ride the river with."

A cowhand named Dick Grigsby told a story that Owens was making biscuits one morning inside his two-room shack when two Navajo horse thieves began firing rounds into his abode from opposite directions. Owens calmly picked up his rifle, walked to the door, shot both raiders and waited quietly for a few minutes before proceeding to finish cooking his biscuits.

At the time of Owens's arrival in Apache County, there were serious problems of civil strife and lawlessness. Among the causes were issues along ethnic and religious lines as a number of groups competed for political and economic power. Mexicans, Mormons, non-Mormons and Navajos all jockeyed for position in the Little Colorado River Valley. Cattlemen competed with sheep men for grazing rights. Texans and Mexicans harbored deep resentment toward each other, dating back to the Battle of the Alamo. There was also contention between the Mormons and Mexicans in St. Johns. The Navajo troubles were mostly over rustling, along with conflicting claims to water and grazing rights. And lastly, the Aztec Land and Cattle Company was trying to rid the country of nesters. Maintaining law and order in Apache County was not a job for the meek.

Holbrook, located at the junction of the Rio Puerco and Little Colorado and straddling the new Atlantic and Pacific Railroad, was soon to become one of the wildest cow towns in the West.

Before the railroad arrived in 1881, Holbrook was known as Horsehead Crossing. The community was renamed Holbrook in 1882 for H.R. Holbrook, who was the first engineer on the Santa Fe (Atlantic and Pacific) Railroad. By 1887, the town had about 250 residents. Businesses included a Chinese restaurant run by a man named Louey Ghuey, Nathan Barth's store, Schuster's store and five or six saloons. Contrary to popular myth, there never was a "Bucket of Blood" saloon. That was a humorous nickname given by the cowboys to any rough-and-tumble drinking establishment.

The social elite of the town included the wide gamut of colorful frontier types: *filles de joie*, gamblers, sheepherders, cowboys and railroaders.

Holbrook in those days was, in the immortal words of Mark Twain, "no place for a Presbyterian," so very few remained Presbyterians, or any other religion for that matter. In fact, the town had the unique distinction of being the only county seat in the United States that had no church until 1913. And

that only came after Mrs. Sidney Sapp cajoled her attorney husband into organizing a fund to build one.

Apache County, in those days, was a vast, rugged area of some 20,940 square miles, larger than Vermont and New Hampshire combined. Originally a part of Yavapai County, it was created in 1879.

The arrival of the railroad in 1881 opened up the plateau country of northern Arizona to large-scale cattle ranching. The territory's most spectacular ranching enterprise, the Aztec Land and Cattle Company, better known by its Hash Knife brand, was running some sixty thousand cows and two thousand horses on two million acres of private and government land. The absentee-owned outfit was literally surrounded by rustlers, who preyed on the herd like a pack of wolves. Many of the rustlers were not outlaws by trade but small ranchers who felt they had a right to rustle Hash Knife stock because the big outfit had taken over public lands.

To expedite the building of transcontinental railroads, the federal government awarded railroads like the Atlantic and Pacific alternate checkerboard sections on both sides of the tracks. The railroads, in turn, sold the land to private corporations. The even-numbered ones remained government property. Thus, if an outfit like the Aztec bought one million acres, its cattle could actually graze on twice that amount.

The nesters figured that if the big outfits could graze their cattle for free on public lands, then they should have a right to harvest a few of those cows.

It was estimated that one and a half million cows occupied the ranges of Arizona. All those cows naturally attracted the lawless element, and soon the ranges were overrun with horse thieves and rustlers. One report claimed fifty-two thousand cows were rustled in one year alone. Convictions for outlawry were rare; the Hash Knife went fourteen years without getting a single conviction for rustling.

The situation had become so desperate that, in the fall of 1887, the Apache County Stock Association hired a range detective to eliminate a few of the most rapacious outlaws in hopes of putting the others to flight. Only two men in the organization knew the identity of the regulator, and they were sworn to secrecy. The association used its entire savings, some $3,000, for bounty money and used its political persuasion to have the hired gun appointed a United States deputy marshal. The gunman, acting as judge, jury and executioner, moved with swift vengeance. Cold and calculating, he shot down two well-known rustlers who "resisted arrest." He then read warrants over their dead bodies. The six-gun justice served up by a mysterious avenging angel was enough to strike terror in the hearts of the rabble and sent many of

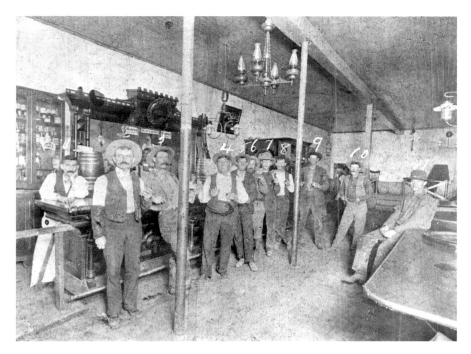

Cowboys bellied up to the bar in Winslow. Note the lack of feminine company. *Courtesy of Southwest Studies Archives.*

them scurrying for other pastures. This mysterious range detective's identity was kept a secret, but it's believed it was Jonas V. "Rawhide Jake" Brighton, a former bad man who became a hired gun for law and order.

By 1886, Owens was working as a deputy sheriff in Apache County. There were some who would later claim that Commodore Perry Owens was also brought in by the association as a hired gun. True or not, he did much to cut down on the population of cow thieves in Apache County. Hailed by the *St. Johns Herald* as the "people's candidate," he was elected sheriff on November 4, defeating incumbent John Lorenzo Hubbell of trading-post fame.

Newspapers rejoiced at the election of Owens, proclaiming he would bring an end to the lawlessness in the county. There was quite a celebration following Owens's victory. In Holbrook, revelers were firing their pistols in the air. George Lee got so caught up in the excitement he accidentally shot his finger off.

Owens received strong support from both the Mexicans and the Mormons, and it was likely their votes that ensured his election. The

previous administration had been anti-Mormon and had slandered them on matters concerning religious beliefs. Both groups believed he was their protector at a time when everyone was persecuting them to get their land and water rights. Also both groups believed Owens was the man to bring law and order to that part of the territory.

Up to that time, Owens hadn't done anything to cause so much public adulation, but he brought honesty and integrity to the office, and that was certainly a refreshing change in Apache County politics. He was also known as a dead shot with both rifle and pistol. He often entertained locals with shooting exhibitions.

Owens's honesty was quickly demonstrated in the way he handled the expenses of the sheriff's office, right down to costs incurred for postage stamps. He cleaned up the county jail, which he described in a report as in a "horribly, filthy condition," and installed rules to restrict problems in the jail.

Two gangs of outlaws in particular were singled out for the new sheriff's immediate attention: the Clanton gang, late of Tombstone, and the Blevins boys, recent arrivals from Texas.

By the time Owens took office, the citizens of Apache County were demanding that both gangs be brought to justice. The *St. Johns Herald* hinted that if the law didn't do its job, the citizens would resort to lynch law.

Ike and Fin Clanton, who had survived the Cochise County War against Wyatt Earp and his brothers five years earlier, had moved their operations to the Springerville area. Their ranch, the Cienega Amarilla, was located east of Springerville, near Escudilla Mountain. The Clantons had been accused of terrorizing local citizens, cattle rustling, train robbery and holding up the Apache County treasurer. Under the leadership of family patriarch Newman Haynes "Old Man" Clanton, they had created a successful business in Cochise County during the late 1870s and early 1880s brokering stolen livestock from Mexico. The old man was killed in an ambush at Guadalupe Canyon in the summer of 1881, and the youngest, Billy, died a few weeks later in the so-called Gunfight at the O.K. Corral.

A story was told around Tombstone that the Clantons often boasted the reason they were so successful in the cattle business was that they didn't have to buy their cows.

Ike was a fairly likeable figure around Tombstone. He had plenty of money to spend around town, and this made him popular among locals. He was also a loudmouthed braggart and, more than anyone else, had instigated the fateful showdown with the Earp brothers and Doc Holliday in Tombstone on October 26, 1881.

When the shooting started, Ike ran away and hid, leaving his younger brother Billy to die. Interestingly, the Earps and Doc Holliday might have been charged with murder had Ike not testified for the prosecution. He got on the stand and with his outlandish tall tales snatched defeat from the jaws of victory for the prosecution. But that's a story for another time.

No doubt, despite his popularity, Ike had many character flaws. Noted Tombstone historian Ben Traywick describes him as "a born loser."

Ike Clanton moved his rustling operation from Tombstone to Springerville. In 1887, he was running away from another confrontation when he was mortally wounded. *Courtesy of Southwest Studies Archives.*

There was so much litigation over rustling in Apache County that Ike Clanton was probably not a high priority. As he did in Tombstone, Ike passed himself off as a successful businessman. He had a lot of money to throw around, and that was good for business.

Other members of the gang included Lee Renfro, G.W. "Kid" Swingle, Longhair Sprague, Billy Evans (who called himself "Ace of Diamonds") and the Clantons' brother-in-law, Ebin Stanley.

On Christmas Day 1886 in Springerville, Evans, wanting to see "if a bullet would go through a Mormon," shot and killed Jim Hale in cold blood.

Apparently Hale had incurred the wrath of the outlaws earlier after he helped identify some livestock they'd stolen.

Five days later, the *St. Johns Herald* wrote of the killing, "During a holiday jollification in Springerville on Christmas Day, the ordinary amusement of pistol shooting was indiscriminately indulged in, and the town ventilated with bullets. Mr. Hale, who was said to have been among the celebrators was shot through the body, from which death ensued."

The Clantons' downfall in Apache County began a few weeks earlier on November 6 with the shooting of a local rancher named Isaac Ellinger at the Clanton ranch. Ellinger and a friend, Pratt Plummer, had ridden to the ranch and had dinner with the Clanton brothers and Lee Renfro. Afterward, Ellinger, Ike and Renfro went into another cabin and were having a conversation when Renfro suddenly pulled his pistol and shot the rancher.

After the shooting, Ike and Fin assured Renfro they were his friends and there was no need to make a hasty exit.

However, when Plummer jumped on his horse and rode for Springerville, Renfro mounted his horse and fled the scene.

As he lay dying, Ellinger called the shooting "coldblooded murder," saying he had no idea Renfro was going to shoot him. He died four days later.

William Ellinger, Isaac's brother, was one of the biggest cattlemen in the West, owning ranches in several states and territories. He was a member of the Apache County Stock Association and had a lot of political clout in the area.

Isaac managed his older brother's ranch and was also a member of the association. His murder would set in motion a strong effort on the part of the association to eliminate the Clanton gang.

In April 1887, the Apache County Stock Association convened in St. Johns and hired a Pinkerton detective to keep an eye on Andy Cooper's gang. At the same time, Sheriff Owens dispatched Apache County deputies Albert Miller and Rawhide Jake Brighton to go after the Clantons. Brighton, along with being constable at Springerville, was a range detective enforcing the law with a mail-order detective's badge.

Originally, on the recommendation of Undersheriff Joe McKinney, Owens had hired the famous former Texas lawman Jeff Milton to go after the Clantons, but at the last minute, he accepted a job as customs officer in southern Arizona.

In May and June 1887, several grand jury indictments were brought against the Clantons and their friends. Most of them involved the murder of Isaac Ellinger. One of the warrants charged Lee Renfro with the murder of Ellinger.

Six-gun justice was closing in on the outlaws. A July 9 edition of the Albuquerque *Morning Democrat* wrote a detailed description of the gunfight at Eagle Creek, stating that Billy Evans, aka Ace of Diamonds, and Longhair Sprague were believed to have met their deaths at a ranch owned by Charlie Thomas in the Blue River country of eastern Arizona. The two, along with either Lee Renfro or Kid Swingle, had ridden into the ranch and, after enjoying the rancher's hospitality, left the following morning, taking with them some of their host's horses.

Thomas and two friends picked up their trail and caught up with the rustlers at the mouth of Eagle Creek. Evans and Sprague pulled their guns and opened fire on the ranchers, who returned fire, killing both rustlers. The third rustler, probably Renfro, escaped.

The *St. Johns Herald* had a different take, claiming the story was a hoax conjured up by friends of the outlaws in order to give them time to escape. Still another twist of the tale claimed the story was made up to protect the posse as to the identity of the person who was actually gunning down the rustlers.

Soon after the gunfight at Eagle Creek, the law finally caught up with Lee Renfro along the border of Graham and Apache Counties. A "secret service" officer, in the employment of a cattlemen's association, recognized him and attempted to make an arrest. Renfro went for his gun, and the officer shot him down.

"Did you shoot me for money?" the dying outlaw asked.

"No, I shot you because you resisted arrest," he replied. The mysterious "secret officer" was the ubiquitous Rawhide Jake Brighton.

About that same time, it was reported that the infamous horse thief Kid Swingle was found hanging from the limb of a tree.

According to reports, Brighton and Albert Miller rode south of Springerville into the Blue River country near the Arizona–New Mexico border looking for Ike and his friends. After three days of hard riding, they stopped to rest at the ranch of James "Peg Leg" Wilson on Eagle Creek. They spent the night there, and the next morning, while they were having breakfast, Ike Clanton rode in. Brighton recognized him and went to the door.

Suddenly Ike wheeled his horse around and bolted toward a thick stand of trees nearby. At the same time, he jerked his Winchester from its scabbard and threw it across his left arm.

Brighton fired, hitting Ike under his left arm, passing through his body and exiting on the right side. Brighton jacked another cartridge into his rifle

and fired again, hitting the cantle of Ike's saddle and grazing his leg. He fell from the saddle and was dead by the time the officers reached him.

Afterward, Wilson rode to the nearby Double Circle Ranch, where he found four of Ike's friends, who returned with him to identify the body.

Ike's body, along with his spurs and pistol, was wrapped in a piece of canvas and buried at the Wilson ranch.

Earlier that year, in April, Fin Clanton had been arrested for rustling and jailed in St. Johns and was still behind bars when Ike was run to the ground. Otherwise, he might have met the same fate as his brother. Fin was convicted in September and sentenced to ten years at the territorial prison at Yuma but was released after serving only two years.

Ike and Fin's brother-in-law, Ebin Stanley, was given sixty days to get out of Arizona. He and his wife packed their belongings and moved to New Mexico.

Whether or not Ike was "resisting arrest" when he was killed is still debated by historians. Despite the official report, there are some today who insist that Brighton was a hired assassin who shot Ike in the back as he was running away. The assassination of known rustlers wasn't all that uncommon in the Old West, where justice was sometime hard to come by. Ike had cleverly managed to elude the law for several years before he was finally driven out of Cochise County.

"Shot while resisting arrest" was a phrase often used to justify exterminating an evasive outlaw who'd managed to escape prosecution by legal means. Towns and cities in the West frequently resorted to vigilante justice when they felt the law was unable or unwilling to protect them. Big ranchers and cattlemen's associations across the West oftentimes hired gunmen to rid their ranges of livestock thieves. The Johnson County War in Wyoming and the story of Tom Horn are classic examples. The legendary Cochise County sheriff John Slaughter acted as judge, jury and executioner more than once.

Author Steve Gatto said it best when he wrote, "The last man standing gets to tell the tale." And so it is.

Although Owens wasn't present at the last roundup of the Clantons and their cohorts, his dragnet was putting a dent in the outlawry in Apache County, and the bad guys were heading for greener pastures.

The other band of outlaws on Owens's hit list was Mart "Old Man" Blevins and his four sons, Andy, Charley, Hamp and John. There was also a younger brother, fifteen-year-old Sam Houston. Twenty-five-year-old Andy, the eldest, used the alias surname Cooper and was singled out as the leader of the gang.

Andy Cooper came to Arizona from Mason County, Texas, sometime in 1884 and quickly saw the lucrative opportunities in the business of stealing livestock. He encouraged his father to bring the rest of his family to Arizona. They arrived in 1886 and set up their "ranching" operations.

The "Old Man," who was only forty-seven, had a fondness for acquiring good horseflesh without paying for it and probably thought the change of scenery would do him and his family good. It turned out to be a bad business decision for them all.

Soon they were driving stolen horses from Utah and Colorado to their ranch on Canyon Creek, ninety miles south of Holbrook.

The outlaws' operations in the area crossed county lines. At the time, Pleasant Valley was part of Yavapai County, and the simmering war between the Grahams and Tewksburys was heating up. Some of the outlawry associated with the feud was spreading into Apache County. It's been said that although Owens remained neutral in the feud, he favored the Tewksburys. The forthcoming shootout in Holbrook would pit the Apache County sheriff against a faction of the Grahams.

In 1887, Holbrook, a town of some 250 residents had a dozen or so frame shacks lined up along Center Street, which paralleled the Santa Fe railroad tracks. The Little Colorado River or *Rio*

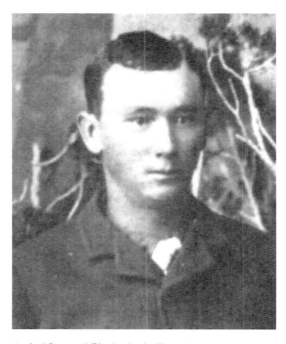

Andy "Cooper" Blevins looks like a clean-cut youngster, but looks are deceiving; he was a coldblooded killer. *Courtesy of Southwest Studies Archives.*

Chiquito Colorado ran just south of town. Half a dozen saloons, two or three stores and a post office lined the south side of the tracks. On the north side was a blacksmith shop, livery stable and several small houses. One of those had been recently occupied by the Blevins family.

For Sheriff Commodore Perry Owens, events were moving rapidly toward his rendezvous with destiny. They say for a gunfighter to get into Valhalla he must have a strong antagonist. That antagonist would appear in the form of a vicious killer named Andy Cooper.

Andy was born on the family ranch near Austin, Texas. Mean enough to eat off the same plate with a rattlesnake, he'd been in trouble with the law since early in his youth. He'd been run out of Indian Territory for peddling whiskey to Indians, and Texas lawmen wanted him for murder and robbery. One story had him making a daring escape from the Texas Rangers by jumping from a train.

The St. Johns newspaper accused him of murder, rustling and forcing small ranchers off their land. The paper also accused him of burning down a church. In May 1887, a group of Mormon ranchers accused him of stealing a herd of cows and selling them in Phoenix.

Two years earlier, Andy had murdered a Navajo youngster and managed to avoid arrest. He killed two more Navajos before being forced to hide out in New Mexico until things cooled off in Apache County. The white citizens of Apache County were beginning to fear that the Navajos would begin taking vengeance on innocent settlers.

According to L.J. Horton's memoirs, Andy robbed and murdered a sheepherder in cold blood near Flagstaff. He then ambushed and killed a witness named Converse and the two lawmen who were pursuing him. Andy netted thirty dollars and, in the process of covering any trace of being linked to the crime, killed four men.

According to an article in the *St. Johns Herald*, Cooper's band openly boasted that peace officers were afraid of them.

Cooper was also a bully. He especially enjoyed browbeating peaceful Mormons in the Rim Country. One story had him ordering a family off their land along Canyon Creek at gunpoint because he wanted the place to rebrand stolen livestock. Other examples of his hooliganism were the pistol-whipping of an unarmed sheepherder and stealing of Navajo horses.

Andy Cooper Blevins wasn't the only one to run afoul of the law. Hamp Blevins, the family's third-born, had done time in the Texas state pen for horse stealing.

In June, Andy, Charley and Hamp left the Canyon Creek ranch and rode to Holbrook for supplies. The morning they left, Mart Blevins rode out to

look for some horses that had been turned out to graze in the canyon. The horses were gone, and he suspected they'd been stolen. He rode back to the house and told his son John he was going in pursuit while the trail was still warm. On the trail, he met a neighbor, and the two went searching for the missing horses. The neighbor returned four days later and told Mrs. Blevins that Old Man was still trailing the animals. Blevins never returned, and his body was never found, but it was suspected that Tewksbury partisans had killed him. It was also claimed they fed his body to the feral hogs that roamed the Rim Country. These were not ordinary hogs, as they were as wild as deer, as big as black bears and as mean as badgers.

The Blevins boys returned from Holbrook and searched the area but found no trace of their dad.

In early August, Hamp joined a small group of Hash Knife cowboys and rode into Pleasant Valley, ostensibly to search for Old Man Blevins. On the ninth, they rode into the old Middleton ranch on Wilson Creek, where they ran into some Tewksbury partisans, got into an exchange of angry words and a gunfight ensued. When the smoke cleared, two men, including Hamp Blevins, were dead.

On September 2, looking for revenge, Andy Cooper and some Graham partisans ambushed a party of Tewksbury partisans in Pleasant Valley, brutally murdering John Tewksbury and Bill Jacobs. Two days later, Andy was in Holbrook boasting that he had "killed one of the Tewksburys and another man whom he didn't know."

Will C. Barnes, in his book *Apaches and Longhorns*, mentions that Sheriff Owens had held a warrant for Andy's arrest for horse stealing for some time but had been reluctant to serve it. Barnes claimed they were "range pals," and "it was common belief that he was avoiding the arrest, feeling sure that one or the other would be killed. Perhaps both, for each man was a dead shot."

The Apache County Stock Association had sworn out the warrant for Cooper's arrest. Barnes was secretary and treasurer of the association. The board was meeting in St. Johns and was aware of the unserved warrant. They summoned Owens and demanded to know why it hadn't been served. Owens said he didn't know where to find Cooper.

According to Barnes, he informed the sheriff that he'd seen the outlaw in Holbrook. Owens was then told that if he didn't arrest Cooper in the next ten days they would remove him from office.

Soon after, the ubiquitous Barnes was working cattle about ten miles from Holbrook when he got word of the pending showdown between the sheriff and Andy Cooper. He hightailed it into town to witness the action.

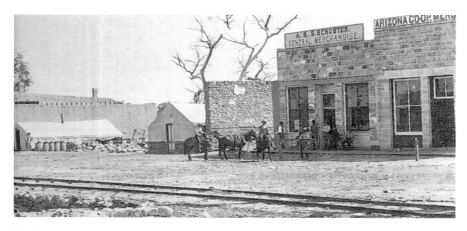

Holbrook during the 1880s. Sheriff Commodore Perry Owens had his shootout with the Blevins boys at a house located near where the photographer was standing. *Courtesy of Southwest Studies Archives.*

"I wanted to see how the little affair would come off," he wrote.

Riding cross county, he arrived in Holbrook just prior to Owens.

The sheriff rode in from the south on a blazed-face sorrel, pausing on a small hill outside of town to plan his next move.

He entered town, put up his horse at Sam Brown's Livery Stable and then walked over to the drugstore owned by Deputy Sheriff Frank Wattron. John Blevins, one of Andy's brothers, was at the stable when the sheriff arrived. He slipped away to warn his brother.

Meanwhile, Barnes made his way to the platform of the railway station, which had a commanding view of the Blevins house.

"There I sat down on a bench," he wrote, "and waited for action."

Justice D.G. Harvey was also present. He later testified that, upon arriving, Owens asked if Cooper was in town. When told he was, Owens said, "I am going to take him in." The sheriff then calmly proceeded to clean and reload his pistol.

Sam Brown offered to go along with Owens to make the arrest of Andy but was told, "If they get me, it's alright. But I want you and everyone else to stay out of it." Owens then cradled his Winchester in his arm and started for the Blevins house on Center Street, about one hundred yards away. A saddled dun was tied to a cottonwood tree a few feet from the house. Barnes described the house as L-shaped with a front porch from which two doors opened.

As Owens approached, he saw a man watching him from an open door. As he drew closer, the door slammed shut. It was now about four o'clock in the afternoon.

The Blevins house on Center Street in Holbrook is today a historic shrine. *Courtesy of Southwest Studies Archives.*

When John Blevins returned to the house with word of Owens's arrival, he was told by his older brother to go get his horse from the stable and bring it to the house. John did as he was told, tying the dun outside the house. Andy was throwing a saddle on the animal when he looked up and saw Owens approaching. He turned quickly and went into the house. Inside were two other men, John Blevins and Mote Roberts, along with young Sam Houston Blevins. Also present were the widow Mary Blevins; her nine-year-old daughter, Artemisia; Eva Blevins, John's wife; their infant son; and Amanda Gladden, along with her infant baby and her nine-year-old daughter.

Frank Wattron, like several others, wanted a front-row seat. He hustled over to the railroad station and sat down next to Barnes.

What happened next is perhaps best described in Commodore Perry Owens's own words:

> *I came in town on the fourth instant, went to Mr. Brown's Stable, put up my horse and about that time Mr. Harvey and Mr. Brown came into the stable. I spoke something of Mr. Cooper, and they told me he was in town, that he comes in this morning. I told Mr. Brown that I wanted to clean my six shooter that I was going to arrest Cooper if he was in town. I came in to clean my six shooter. Someone came after a horse in the corral* [John Blevins].

Mr. Brown says to me, "That fellow is going to leave town."

I told Mr. Brown to go saddle my horse; if he got away I would follow him. I did not wait to clean my pistol. I put it together without cleaning it, went into the stable, and asked the man who cleans the horses if that man had saddled that dun horse. He said no.

I says, "Where is his saddles?"

He says, "His saddle is down to the house."

I asked him where the house was. He told me the first one this side of the blacksmith shop. I went and got my Winchester and went down to arrest Cooper. Before I got there, I saw someone looking out at the door. When I got close to the house, they shut the door. I stepped up on the porch, looked through the window and also looked in the room to my left. I see Cooper and his brother [John] and others in that room. I called to Cooper to come out. Cooper took out his pistol and also his brother took out his pistol. Then Cooper went from that room into the east room. His brother came to the door on my left, took the door knob in his hand and held the door open a little. Cooper came to the door facing me from the east room. Cooper held this door partly open with his head out.

I says, "Cooper I want you."

Cooper says, "What do you want with me?"

I says, "I have a warrant for you."

Cooper says, "What warrant?"

I told him the same warrant that I spoke to him about some time ago that I left in Taylor, for horse stealing.

Cooper says, "Wait."

I says, "Cooper, no wait."

Cooper says, "I won't go."

I shot him.

This brother of his to my left behind me jerked open the door and shot at me, missing me and shot the horse which was standing side and a little behind me.

According to Barnes's account, John Blevins fired at Owens with a pistol from about six feet away. He missed, and the bullet hit Cooper's horse squarely between the eyes. The animal jerked back, breaking the reins and galloped off a few yards down the street before dropping dead.

"I whirled my gun and shot at him," Owens continued, "and then ran out in the street where I could see all parts of the house."

John Blevins slammed the door after firing his pistol. Owens fired through the door, and the bullet tore into Blevins's shoulder, taking him out of the fight.

> *I could see Cooper through the window on his elbow with his head towards the window. He disappeared to the right of the window. I fired through the house expecting to hit him between the shoulders.*

Owens fired again, this time sending a bullet crashing into Cooper's hip. "I stopped a few moments," he continued.

> *Some man* [Mote Roberts] *jumped out of the house on the northeast corner out of a door or window, I can't say, with a six shooter in his right hand and his hat off. There was a wagon or buckboard between he and I. I jumped to one side of the wagon and fired at him. Did not see him anymore.*

Owens's fourth bullet passed through Roberts's chest, wounding him fatally.

> *I stood there a few moments when there was a boy* [Sam Houston Blevins] *jumped out of the front of the house with a six shooter in his hands. I shot him. I stayed a few moments longer. I see no other man so I left the house. When passing by the house I see no one but somebody's feet and legs sticking out the door. I then left and came on up town.*

When it was clear no one else was coming out of the house, Owens turned and walked back toward the livery stable. The gunfight lasted just three minutes. Several townspeople suddenly appeared on the street. Local justice of the peace A.F. Banta asked, "Have you finished the job?"

Owens looked at him and curtly replied, "I think I have."

In the span of a few short minutes, Owens had faced four guns. Only one shooter, John Blevins, had gotten a shot off, and in his haste, he missed. Owens fired five times. He didn't miss. Sam Houston Blevins died instantly of a bullet in the chest. Mote Roberts lingered a few days before expiring, and John Blevins eventually recovered from a shoulder wound. Andy Cooper lived a few hours, suffering painfully from his wounds before giving up the ghost, and perhaps had some time to reflect on his savage life.

Slain outlaws often grow halos. Following the "street fight" in Tombstone, Billy Clanton and the McLaury brothers were pictured in death by their supporters as unarmed, happy-go-lucky cowboys just having a little fun. It

was the same with the Blevins boys. Listening to members of the family testify at the inquest, one would think the boys in the house were all unarmed and discussing what they'd learned in Sunday school class that morning when Sheriff Owens stepped up on the porch.

At the inquest that followed, family members and friends saw the fight differently, claiming Andy was unarmed, which seems odd considering he knew the sheriff was coming.

Amanda Gladden, who was inside the house, claimed she never saw any of the Blevins men holding weapons.

Mote Roberts lingered in pain for eleven days before expiring. He lived long enough to testify at his own inquest. Roberts swore he was unarmed and, at the first sound of gunfire, dove out the window to escape.

John Blevins swore he never fired a shot.

Mary Blevins, Sam's mother, said, when asked if he had a pistol, "Not that I know of; if he did I don't remember it."

Witness D.B. Holcomb testified about the shooting of young Sam Blevins: "If the boy had a pistol I did not see it."

But Dr. T.P. Robinson, who attended the youngster, testified he was holding a pistol.

Contrary to Mote Roberts's sworn testimony, there is evidence he dove out the window holding a pistol.

John Blevins explained the spent shell in his revolver occurred when he fired a round as he was riding into town with Andy.

The testimony of several other reliable witnesses, including Frank Wattron, Henry F. Banta and Will Barnes, supported the sheriff. In the end, an inquest exonerated Sheriff Owens in the killing of all three men.

A few days later, the *St. Johns Herald* said, "Too much credit cannot be given Sheriff Owens in this lamentable affair. It required more than ordinary courage for a man to go single-handed and alone to a house where it was known there were four or five desperate men inside, and demand the surrender of one of them…outside of a few men, Owens is supported by every man, woman and child in town."

Today historians still differ on whether Sheriff Owens was a lawman doing his duty or an executioner; however, most historians generally accept Owens's account of the fight.

Rim Country historian Jayne Peace Pyle has spent years studying the Pleasant Valley War and is no fan of Owens. She told the author, "Owens and Andy Cooper Blevins were comrades in crime when Cooper Blevins first came to Arizona. Owens had told Andy that he would not serve that

warrant on him. When Owens knew he had to serve the warrant to keep his job, he knew he had to kill Andy—and kill without warning—which he did, or Andy would have killed him."

She makes a good point when she says, "Personally, I think it was terrible for Owens to go to Mrs. Blevins's home and shoot into a house with women and children inside. Surely he could have cornered Andy somewhere outside. One of the babies was so covered with blood, they thought it had been shot! I know a lot of people see Owens as a brave man, but I don't."

Barnes offered a description of the interior of the Blevins house:

> *The interior of the cottage was a dreadful and sickening sight. One dead boy, and three men desperately wounded, lying on the floors. Human blood was over everything. Two hysterical women, one the mother of two of the men, the other John Blevins young wife, their dresses drenched with blood, were trying to do something for the wounded.*

Poor Mary Blevins was the real casualty of war. Matriarch of the family, she had lost her husband, Mart, and son Hamp a few weeks earlier in the Pleasant Valley Feud. Two more sons died in the fight with Sheriff Owens, and another was seriously wounded. A month later, another son, Charley, would be gunned down by a posse while resisting arrest outside the Perkins Store in Pleasant Valley.

In her book, *Women of the Pleasant Valley War,* Jayne Peace Pyle writes about Mary Blevins's losses:

> *Her world was turned upside down. I think almost any woman and some men could identify with her feelings. Mary's loss was so great! I think this is the one thing that turned public opinion against C.P. Owens. He attacked a house full of women and children. Anyone of them could have been killed.*

John Blevins, the lone survivor of the fighting Blevins family, was sentenced to five years in the Yuma Territorial Prison for his part but was released without doing time. He later became a deputy sheriff and, in 1901, was shot in the shoulder by drunken soldiers just a few feet from the old Blevins house. He eventually moved to Phoenix, where he engaged in ranching and, in 1928, was appointed Arizona State Cattle Inspector. Two years later, he was killed by a hit-and-run driver near Buckeye.

Author Jo Baeza, who's been writing about the history of the area for more than fifty years, is a great admirer of Owens:

I don't agree with those writers who criticize Owens. He will always be a hero to me. And, I don't agree with a lot that Will Barnes wrote because he liked to embellish. I do have faith in court records, testimonies, and men like Frank Wattron.

One of the things I learned after talking to many people back 50 years ago is how much the Mexican and Mormon people loved Owens. He was their protector at a time when everyone was persecuting them to get their land and water rights.

Just for fun he used to put on shooting exhibitions for the LDS settlers on July 4th. He'd shoot his initials in a tree trunk while riding at a gallop. No matter what opinion people have of him, there is no doubt he was one of the best marksmen in the West.

The courage of Commodore Perry Owens cannot be disputed. He refused assistance, including that of his deputy Frank Wattron, and went to arrest Andy Cooper alone. He wound up in a gunfight with four men and dispatched them all singlehandedly.

As so often happened in the Old West, citizens in need of law and order cried out for a fearless gunfighter to come riding in and rid the place of the bad guys. And after the six-gun Galahad's work was finished, he became something of an embarrassment to the community. Civic leaders in Apache County became antagonistic toward their sheriff after the gunfight at the Blevins house.

A story is told that one time, after the board of supervisors refused to pay money owed, Owens walked into a meeting, drew his revolver and demanded he be paid. The nervous supervisors paid up without delay.

"I don't believe the story that he pulled a gun on the board of supervisors to get his pay," says Baeza.

He would not have done that. He didn't pull a gun on anybody unless he intended to shoot them. It's true they withheld his pay to try to get rid of him after the Blevins shootout, but they didn't know him very well. Jake Barth told me this story and he would have known. He even showed me the room Owens had before they tore down the old hotel. An upstairs room overlooking the main street. Owens boarded at the Barth Hotel in St. Johns. When the supervisors met, he paid his bill at the hotel, packed a horse with his belongings, armed himself, and rode up to the courthouse, leaving his horse outside as if he was ready to get out of town. They got the message and paid him what they owed him. After he got paid, he rode back to the

hotel, unloaded his stuff and moved back in. As far as I know that ended the games the supervisors were playing with him. It also shows Owens had a sense of humor.

Sheriff Commodore Perry Owens didn't always find success in his pursuit of outlaws. An example was Red McNeil, a reckless, carefree Hash Knife cowboy who, at the age of twenty, decided to become a desperado. He might not be remembered in the annals of outlawry if he hadn't had a propensity for leaving clever poems at the scene of his crimes. Usually they were meant to insult the lawmen in pursuit. Red was believed to have come from an affluent family back east and had even gone to college. He once confided to a friend that he'd been educated to become a Catholic priest.

In early 1888, Red was in jail in Phoenix on a charge of horse stealing but escaped and stole another horse. He was recaptured and locked up in Florence but got away again. This time Red headed for Apache County, where he took a load of buckshot while attempting to rob Schuster's merchandise store in Holbrook. Red was making his getaway but still found time to pen this poem and tack it to a tree on the banks of the Little Colorado River:

> *I'm the prince of the Aztecs;*
> *I am perfection at robbing a store;*
> *I have a stake left me by Wells Fargo,*
> *And before long I will have more.*
>
> *There are my friends, the Schusters,*
> *For whom I carry so much lead;*
> *In the future, to kill this young rooster,*
> *They will have to shoot at his head.*
>
> *Commodore Owens says he wants to kill me;*
> *To me that sounds like fun.*
> *'Tis strange he'd thus try to kill me,*
> *The red-headed son-of-a-gun.*
>
> *He handles a six-shooter neat,*
> *And hits a rabbit every pop;*
> *But should he and I happen to meet,*
> *We'll have an old-fashioned Arkansas hop.*

Not much chance for a Pulitzer Prize here but not bad for an outlaw on the run.

Red McNeil crossed the border and hired out at the WS Ranch in New Mexico. The affable redhead made friends easily, entertaining the cowhands with his mouth harp and clog dancing. Everyone thought he was a great guy until he suddenly vanished, taking with him the ranch's prize thoroughbred stud.

Late in 1887, near the Arizona–New Mexico border, Sheriff Owens was still searching for McNeil for the Shuster's robbery. He rode into a cow camp one night, asking if anyone was acquainted with the redheaded outlaw. None of the cowhands could rightly say they'd had the pleasure of Red's acquaintance. The lawman was invited to stay the night, and having no bedroll, one of the punchers generously offered to share his blankets.

The cowhands rode out at daybreak, leaving Owens asleep in camp. He awoke to find a note in familiar handwriting from the man who shared his bedroll. Despite being in a rush, he did pen a short good-natured poem to the sheriff:

> *Pardon me, sheriff*
> *I'm in a hurry;*
> *You'll never catch me*
> *But don't you worry.*
> *Red McNeil*

Sheriff Owens's reaction to this affront is not known.

In 1889, the law finally caught up with the popular, devil-may-care outlaw Red McNeil. He was arrested and convicted on a charge of train robbery and served ten years in prison. In prison, he educated himself to be a hydraulic engineer and went on to live a respectable life. Many years later, he returned to Holbrook and visited Schuster's store. The former outlaw fully hoped there were no hard feelings and was assured the past was all water under the bridge.

After his term expired in January 1889, Owens returned to his ranch near Navajo Springs and raised prize horses. He was a special agent for the Atlantic and Pacific (Santa Fe) Railroad for a time and then an express messenger for Wells Fargo. Later he served as a U.S. deputy marshal for several years. In 1894, he made an unsuccessful run for Apache County sheriff, and the following year he was appointed sheriff of newly created Navajo County, carved from the western part of Apache County. He made a bid for a full term in 1896 but lost in the general election.

Owens was an honest, dutiful lawman who accomplished his primary mission—that of running the rustler gangs to the ground. Unfortunately, he was also perceived by many as a man-killer, and this no doubt hurt his political career. He wasn't the first "good man with a gun" who was brought in to bring law and order only to be turned away by the good citizens when his services were no longer needed.

In 1902, he settled in Seligman, opened a saloon and married Elizabeth Barrett. He'd hung up his shooting irons by this time and ran a successful business until he died on May 10, 1919.

There's no doubt Commodore Perry Owens was a man with the bark on. Will Barnes pretty well summed up his "fifteen minutes of fame" in Holbrook that September day when he wrote, "In all the wild events in Arizona's wildest days there is nothing to surpass this affair for reckless bravery on the part of a peace officer."

5

CLIMAX JIM

ARIZONA'S LADY GODIVA

C limax Jim was the darling of the Arizona press during the late 1890s. Thanks to the fertile imaginations of the old-timers who knew him and the newspaper reporters who embellished and enlivened his activities, this likable streetwise kid from the East Coast matured into a prominent escapologist, rustler and rascal. His suggestive sobriquet also made him something of a public curiosity.

His colorful confrontations with the law weren't exactly the stuff of legends, but they kept readers thoroughly entertained.

His real name was Rufus Nephew, and contrary to what readers might be thinking, he picked up the nickname Climax Jim because his favorite chaw was the popular Climax Chewing Tobacco.

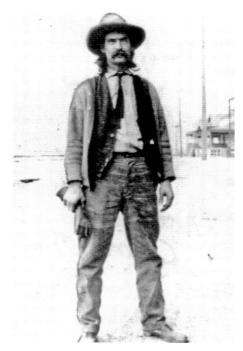

Climax Jim, whose real name was Rufus Nephew, was a favorite subject for newspaper reporters during the latter part of the nineteenth century. *Courtesy of Southwest Studies Archives.*

Climax Cut Plug Chewing Tobacco, "the Grand Old Chew," was a favorite of nineteenth-century baseball players and evidently at least one cattle rustler. Climax Jim told Tucson reporter George Smalley in 1902 that he arrived in Arizona using the alias Kid Thomas but soon picked up another.

"I used to like tobacco right well," he said, "and when I was just a kid I lit into the camp of the Hash Knife outfit in northern Arizona and was going on roundup for a month. So, I just laid in a supply of tobacco—twelve pounds of Climax in a gunnysack and a full bar tied to my saddle…At the end of twenty-five days I had 'chewed' every leaf of that tobacco, there wasn't a puncher in their outfit that wasn't calling me 'Climax Jim.'"

His reputation for using a chaw resourcefully reached new heights when he was arrested for altering a check and trying to cash it. When his trial came up, the check was placed on a table in the courtroom as Exhibit A for the prosecution. In the opening arguments, his lawyer got into a nose-to-nose argument with the prosecuting attorney. During the distraction, Climax Jim, with a chaw of tobacco creating a round bulge in his cheek, ambled over to the table and stuffed the check into his mouth.

The judge finally restored order and directed the prosecuting attorney to present Exhibit A. When he reached for his primary evidence, it was nowhere to be found. A few feet away, Climax sat there in his chair chewing his cud with an air of innocence that would have done a choirboy proud.

The case was dismissed for lack of evidence. As he was leaving, Climax, with all the aplomb of a muleskinner, spit Exhibit A into the judge's personal spittoon.

On another occasion, he was indicted for stealing cows in Graham County, but when the trial came up, he produced witnesses who swore the crime was actually committed in Apache County. He was acquitted and immediately arrested in Apache County for stealing the same cattle. This time he produced witnesses who swore the crime was committed in Graham County, and he was acquitted again.

Climax Jim was only sixteen in 1894 when he was arrested the first time after he sold a dozen steers to a slaughterhouse in Winslow.

Lawmen soon learned that capturing him was a lot easier than keeping him in jail. That night, using a pocketknife, he tunneled his way out of the adobe building and said "adios" to Winslow.

A few months later, on July 4, he celebrated the holiday by stealing a horse in Gila County. County sheriff John "Rim Rock" Thompson caught up with him in Pleasant Valley and headed for Globe with his prisoner. They camped along the way, and Thompson chained his prisoner to a post. During the night, Climax

busted a link and fled on foot. After a long chase, he was captured a few miles south of Globe and hauled into jail. It took a couple of months, but he escaped again, this time using a spoon to dig through the mortar and removing enough bricks to crawl through, inspiring Globe residents to dub him "the Spoon Kid."

Climax stole a horse in Globe and headed south. Near the old mining town of Mammoth, his horse played out, and he stole another before he was captured again outside Benson. This time the seventeen-year-old rustler was sent to the territorial prison at Yuma to serve a one-year sentence.

Years later, Climax boasted he had escaped from every jail in the territory except Yuma's notorious "Hell Hole."

One Arizona newspaper wrote, "Climax Jim is easily the most slippery jail bird in the Southwest." Another proclaimed, "It is an old saying that the third time is the charm but Climax has been arrested and tried about forty-seven times and he has always succeeded in getting in the clear."

Another time Climax was being taken to jail handcuffed to a lawman. They stopped to camp, and sometime during the night he managed to pick the lock. When the officer awoke the next morning he found his own hands handcuffed, and his prisoner had vamoosed.

Climax Jim also garnered quite a reputation as a lock picker. Upon being locked in a cell, he'd inform the sheriff that he'd bust out before morning, and sure enough, he'd be gone again. Another time, he picked the lock and was sitting in the sheriff's chair wearing a big grin when the lawman showed up for work the next morning.

He got a chance to demonstrate his skill as a safe cracker when a Clifton storekeeper ordered an expensive burglarproof safe. Climax was at the train depot when the safe arrived. He started playing with the dial, and to the delight of a group of curious onlookers, in less than thirty minutes—shazam—the safe door was open.

Upon leaving the territorial prison, Climax returned to the wild Black River country that served as a sanctuary for a number of notorious outlaw gangs, where he resumed his career as a rustler. Whether he rode with one of those gangs is a matter of speculation, and even though the evidence says otherwise, Climax always insisted his was a one-man operation.

In June 1898, he was allegedly captured again for rustling and taken to the Apache County seat at St. Johns, this time by Hash Knife superintendent Burt Mossman, who in 1901 would become the first captain of the Arizona Rangers, a group mainly organized to thwart the gangs of rustlers working in the rugged mountains of eastern Arizona. During the night, Climax sprang the lock and escaped.

In 1902, he alluded to reporter Smalley that he had been part of a bunch of desperadoes known as the Bronco Bill gang. On March 28, 1898, they attempted but failed to rob a Santa Fe train at Grants, New Mexico. A few weeks later, they pulled a successful heist of the southbound Santa Fe a few miles outside Belen on May 24. Then on August 14, they tried to hold up the westbound Santa Fe again at Grants. The crew put up a fierce fight, and the gang withdrew empty-handed. Even though some thirty shots were fired at close range, no one was hit. The only gang member identified was Red Pipkin.

There's evidence Climax was tied in with the gang, but his forte seemed to be stealing cows and getting caught, probably because he was always the "usual suspect."

Climax celebrated New Year's Day 1899 facing an indictment for brand burning again, this time in Graham County. A few weeks later, he celebrated Washington's Birthday by escaping from the well-guarded jail with three others. After a few days of wandering afoot, the four fugitives were captured along Eagle Creek and returned to jail.

On the morning of March 6, Graham County sheriff Ben Clark fitted Climax Jim with a new pair of leg irons riveted shut by the local blacksmith. Two days later, the jailer noted he'd managed to break the shackles, but before the blacksmith could arrive to make repairs, Climax had scaled the adobe walls and was running for freedom, only to be caught a few minutes later.

Climax's trial date was set for the fall term. Some friends posted bond, and he was temporarily freed.

Climax didn't waste any time going back to his old ways. In May, he was out riding and spied a small bunch of cattle belonging to the Chiricahua Cattle Company. There were no CCC cowhands in sight, Climax thought to himself; it would be a neighborly gesture if he drove the little herd along a ways until he found the owner or a roundup, and then he would turn them over to their proper owners. And if he didn't come across anyone, he would just keep driving them on to New Mexico. Thus the Star-Bar-Circle Cattle Company was born. He was president, board of directors, superintendent, range boss, wrangler and roundup cook, all rolled into one.

Meanwhile, down south, the range boss of the CCC missed his little band of cows and followed the trail. He notified the sheriff of Apache County to intercept the usual suspect, Climax Jim, and throw him in the Springerville jail.

There are a couple of versions of what happened next. One has it that on the night of July 7, 1899, Climax managed to escape from his leg shackles. He removed his clothes and waited for the jailers to enter his cell

and adjust the leg irons. He threw his clothes in the turnkey's face and, after a brief struggle with the other, made his escape on foot.

I prefer the other story that says that, while awaiting his arraignment, officers decided he needed a bath so they armed him with a large brush and a bar of soap and pointed him toward a nearby horse trough. He was about to climb in when he spied a good-looking horse tied to a hitching post.

In a flash (no pun intended) he mounted up, and in a scene reminiscent of Lady Godiva's storied ride through Coventry, he galloped out of Springerville *and* Eager, making his escape into the mountains.

The fabled Lady Godiva rode through town nude, and because of her ravishing beauty, none dared look at her. Climax Jim outdid the lovely lady by riding through *two towns* in his birthday suit. History didn't record whether or not anybody stared or turned their head away in disgust.

Climax Jim died with his boots on but not by the gun in the way a good outlaw should. Eventually, he gave up his lawless ways and took an honest job digging wells in San Diego, where, ironically, he met his untimely end in 1921, falling to his death when the scaffold he was on collapsed. In the case of Climax Jim, stealing cows, outwitting peace officers and escaping jail might have been a safer way to make a living.

6

TEXAS JOHN SLAUGHTER

John Horton Slaughter was one of the many Texas drought–stricken cattlemen who drove their herds to the virgin ranges of Arizona in the 1870s. He settled in Cochise County and eventually bought the historic San Bernardino ranch that straddled the Mexican border in southeastern Arizona.

Slaughter typified the nineteenth-century rawhide-tough breed that settled and tamed the wild Southwest border country. He was born in 1841 in Sabine Parish, Louisiana, and brought as an infant to Texas. His father, Ben, was a cattleman engaged in rounding up wild longhorn cattle in the brush country of south Texas. When he was fourteen, the family moved to Pleasanton, in the San Antonio area. During the Civil War, he joined the Confederate army but was mustered out in 1862 because of tuberculosis. He immediately enlisted in the Texas Rangers and spent the next few years fighting Indians.

In 1871, John and his two brothers, Charlie and Billy, gathered some wild cattle and started the San Antonio Ranch, but soon he went out on his own. It was said that on cattle drives he'd start out with five hundred head and by the time he reached the market he'd have some three thousand head wearing his brand. Old-timers would later say Slaughter's cows were a biological phenomenon because each cow had eight or more calves a year.

There was a different set of rules along the Mexican border. Both the Americans and the Mexicans cut through bureaucratic red tape and dealt with issues in a more practical way. The head of the Mexican

Rurales was Colonel Emilio Kosterlitzky, a Russian-born soldier who ruled northern Mexico with an iron fist. Outlaws and murderers were seldom brought to trial but were executed on the spot. He cooperated with American peace officers, delivering wanted men without going to the trouble of extradition proceedings.

Slaughter wasn't shy of chicanery when it came to bending the rules. He'd notify the border inspectors he was bringing fifteen head of cattle across the line at Guadalupe Pass, and while the inspectors were distracted counting the fifteen head, his cowboys would be driving another hundred at another place along the border. Stories are legion of how Slaughter avoided red tape. One time when he was bringing a large herd across the border, he notified the inspectors that a large smuggler train was crossing that night at a certain point along the border. Naturally, they were much more interested in gathering a cache of smuggled goods than counting John Slaughter's cows. Not an inspector was in sight when the herd crossed the border.

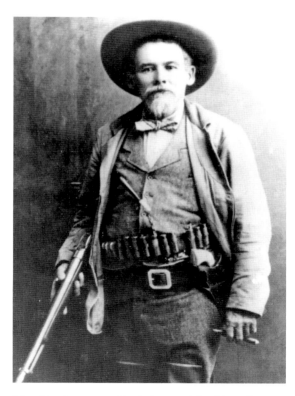

He stood only five feet, six inches and had dark, penetrating eyes. He always believed he was protected by a guardian angel and couldn't be killed. The many times he stared death in the eye seemed to bear that out. "I'll die in bed," he declared, and he did... eventually and at a ripe old age.

Slaughter liked to smoke cigars and play poker, and he had a hot temper. He had a curious habit of prefacing his remarks with "I say, I say." For example if he was in

John Slaughter was a Confederate soldier, Texas Ranger and rancher before he settled in Arizona. In 1886, he was elected sheriff of Cochise County. *Courtesy of Southwest Studies Archives.*

a poker game and suspected some cheating was going on, he'd say, "I say, I say! There seems to be too [many] aces in this deck of cards." That was always enough to end the cheating.

He was a product of frontier life, a lawless and violent post–Civil War era. He had no problem killing a man if he believed the man needed killing. He packed a pearl-handled .44 and a shotgun. Some said he was a good man, and some said he was bad, but they all agreed: John Slaughter was all man. Slaughter might have killed twenty men or more, but he never said. One of his deputies described him as "a man of few words and he used them damn seldom."

After he became sheriff of Cochise County in 1887, he issued a warning to the rustler gangs: "Get out or get shot." Most took his advice and left the country. Those who didn't usually wound up fertilizer for spring flowers. In running outlaws to the ground, he frequently acted as judge, jury and executioner. Nobody asked questions, but law-abiding citizens were glad the undesirables were gone and wouldn't return,

"His name is Slaughter, all right," said one Tombstone observer, "but he wasn't in any way the sort of a man we used to call a 'killer.' He didn't like to shoot people. He did it simply because it was in the day's work, was his duty, and it was for a good purpose."

When dealing with the lawless element, John Slaughter was ruthless, but he had another side, too. He met Eliza Adeline Harris, the beautiful daughter of a wealthy Texas rancher. John was thirty and ready to settle down, but her mother opposed the marriage. However, love won out, and the two were married in 1871 in San Antonio. Two of their four children died in infancy.

While traveling across Arizona in 1877, John decided Texas was too crowded, and he began planning a move to Arizona. Eliza and the children would join him there. Sadly, she contracted smallpox during her trip and died soon after she arrived in Phoenix. The two surviving children were stricken and quarantined by the dreaded disease, but John tenderly nursed them back to health.

It was just a few months before this tragic event that one of John Slaughter's most famous gunfights occurred. His adversary was a New Mexico cattle rustler named Barney Gallagher, "the Man from Bitter Creek." Trouble between the two had been brewing ever since an argument over a game of poker.

In the fall of 1876, Slaughter caught Gallagher surveying his herd. He warned the outlaw to make tracks, but a few days later, Gallagher returned

and charged Slaughter, armed with a shotgun and two blazing .45s. After Slaughter shot his horse out from under him, Gallagher got up and charged again. Slaughter coolly dropped him in his tracks.

Gallagher's last words were, "I needed killin' twenty years ago anyway."

However, New Mexico governor Lew Wallace saw it differently. He also considered Slaughter a cattle thief and declared him number one on his wanted list. Also listed was number fourteen, William "Billy the Kid" Bonney.

In 1879, the governor had Slaughter arrested for murder, but the cowman was soon released for lack of evidence. He decided it was time to leave New Mexico.

After the death of Eliza, John Slaughter believed he'd never marry again, but while driving cattle near the Pecos River, south of Roswell, Cupid struck again; this time it was eighteen-year-old Cora Viola Howell, the beautiful daughter of cattleman Amazon Howell and his wife, Mary Ann. Her father was overjoyed at the prospect, but his future mother-in-law went into hysterics. John was twice her daughter's age, and he had two small children that she'd have to raise. But Mary Ann soon gave in and eventually became one of his biggest fans. The marriage lasted more than forty years.

The newlyweds settled first in the Sulphur Springs Valley but soon moved over the San Pedro River near Tombstone and then to Charleston, where he opened a meat market.

At the time, the Earp-Cowboy feud was going strong, but Slaughter didn't take sides. He had no love, however, for his neighbors, the Clantons. He'd been missing cattle and one day caught Ike on his range. He warned Ike that he would kill him and his kin if it happened again. It didn't, and the rustling stopped.

In 1886, the citizens of Cochise County elected him sheriff, an office he would hold for two terms. He could have stayed on but felt he'd done enough, and he wanted to get back to his family and the ranch. His successor, famed photographer C.S. Fly, appointed him deputy, a position of honor he held until his death in 1922.

He'd purchased the old San Bernardino Land Grant ranch in 1884. Consisting of some sixty-four thousand acres, one-third was in Arizona and the other two-thirds in Sonora. It was blessed with plenty of water, the necessary ingredient in western ranching, and a small community developed around it. Before long, an empire that would become one of Arizona greatest ranches was running cattle on a quarter million acres from the Chiricahua Mountains to the Sierra Madre.

When the Apache bands raided his cattle herd, Slaughter took offense and went into their lair. Usually he didn't wait for them to raid his outfit. When he saw signs of their presence, he'd go on the offensive. Eventually, they avoided his ranges. Years later, at Fort Sill, Geronimo commented that before he died he'd like to go back to Arizona and kill John Slaughter. Slaughter took that as a compliment. Incidentally, Geronimo surrendered in 1886 in Skeleton Canyon on Slaughter's range.

On the other hand, Slaughter, like Henry Clay Hooker at the Sierra Bonita, in northern Cochise County, allowed hungry Apaches to butcher a beef when necessary.

In 1907, Slaughter was elected to the territorial legislature and served a single term. But ranching was his life, and he was never happier than when he was at the San Bernardino with his family.

By now, "Old Dad Time" was catching up with John Slaughter, but he still had plenty of fight left in him. During the Mexican Revolution, Pancho Villa's men were butchering his cattle to feed their army near Agua Prieta. Slaughter grabbed his gun, mounted his horse and rode boldly into Villa's camp with fire in his eyes. He returned home later with his saddlebags full of shiny new twenty-dollar gold pieces. Not even Pancho Villa was willing to tangle with the man some called "the wicked little gringo."

His last battle occurred on May 4, 1921, when he and Viola, armed with shotguns, held off several bandits who were out to rob the ranch. He was eighty-one.

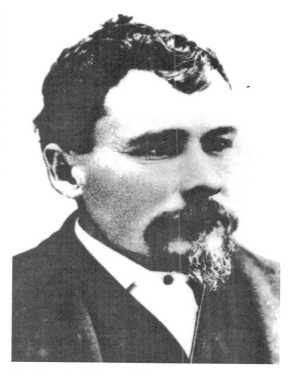

John Slaughter's last gunfight occurred on May 4, 1921, when he and his wife, Viola, armed with shotguns, battled a band of outlaws. *Courtesy of Southwest Studies Archives.*

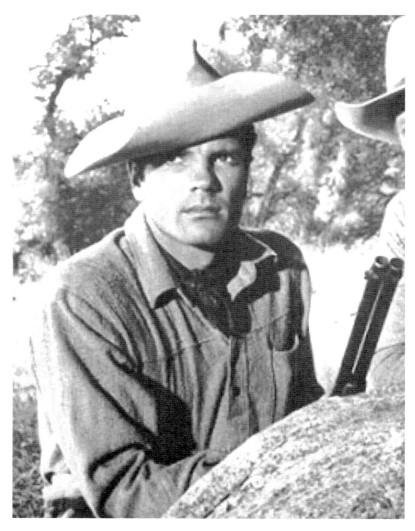

Actor Tom Tryon starred in *Texas John Slaughter* on the Wonderful World of Disney television series from 1958 to 1961. *Courtesy of Southwest Studies Archives.*

Slaughter died the following year in Douglas, the town he helped establish.

John Slaughter was small in size but great in frontier stature. He was a lawman, cattleman, gunman, gambler, businessman, pioneer and empire builder. He was sometimes a bit careless about the legal niceties of the law, but it was a rough, tough country, and it took men with bark on to tame it. His name will be long remembered in the annals of great westerners.

GEORGE RUFFNER

SHERIFF OF OLD YAVAPAI

He enjoyed the pleasures of Prescott's Whiskey Row, but he was much more than a reveler. George Ruffner was elected sheriff more times than any other lawman in Arizona. After a long chase, he hanged the cowboy who had taught him cowboy skills.

Budge Ruffner used to tell a story about his uncle George's disdain for the political arena. George was sheriff of Yavapai County and a good one. But he hated campaigning for office. While other politicians were out stumping for votes, making long-winded political speeches at the plaza at the Prescott Court House, George would get up, walk to the podium and say, "I'm George Ruffner; I'm running for sheriff." Then he would sit down.

There was a man in town named Sandy Huntington who thought the sun rose and set on Sheriff Ruffner. Sandy was from that prominent Huntington family in California, but he had a serious drinking problem and was something of an embarrassment at family gatherings so they banished him to Arizona. The sheriff took sympathy on Sandy and gave him odd jobs to do around his livery stable. In return, Sandy gave Ruffner his undying loyalty.

One election year, George Ruffner was getting some stiff competition from the loyal opposition, and Sandy became concerned because the sheriff refused to campaign vigorously. Despite the challenge, he still campaigned in the same lethargic way. By election day, the race was too close to call so Sandy decided to do what he could to swing the election to his hero.

Sandy volunteered to work at the voting booth assisting the illiterate voters. The law required that not being able to read and write shouldn't keep one from exercising their right to vote. So Sandy's job was to read the names of the candidates and mark their ballot.

He would come to the office of sheriff and announce the candidates: "Democrat, George Ruffner; Republican, Pinky Graveldinger."

If the voter said, "Sandy, I want to vote for George Ruffner," Sandy would happily reply, "One vote for Sheriff Ruffner." And he'd mark an "X" in the square next to George Ruffner's name.

However, if the voter said he wanted to vote for "that Republican fella," Sandy would mark a big "X" in the square next to George Ruffner anyway and say with assurance, "By God, we'll just cross out that Democrat SOB!"

It's hard to say how much Sandy Huntington helped George Ruffner win elections, but one thing is certain: he was elected to office more times than any other sheriff in Arizona history.

His family roots were already planted in Arizona history when George arrived around 1880. His uncle, Morris A. "Andy" Ruffner, was one of the first Americans to mine copper at Cleopatra Hill, high above the Verde Valley, where the town of Jerome would come into existence.

Tall and lanky at six feet, four inches, George rose above the crowd. He was a popular sheriff with a reputation for fair play and was as comfortable atop a good horse as he was in the presence of a decent lady. An intrepid, fearless lawman, he always got his man. It was said he could track bees in a blizzard. George also liked to take in the games of chance in the gambling joints along Whiskey Row in Prescott. It was said he lost $1,700 one night on the turn of a single card. It was also said he lost $38,000 the last night before gambling was outlawed in 1907. Ole Dame Fortune did smile on him occasionally though. One night in the Palace Saloon, he won the Prescott mortuary that still bears his name in a game of six-card stud. He won that game with a pair of sixes, and sometime later, he bought a ranch outside Prescott and registered his brand: two sixes, or 66.

It was July 14, 1900, on a typical Saturday evening. Sheriff Ruffner looked at the drunks celebrating on Whiskey Row and mused, "We'd have to wall in the whole town and put a roof over it if we had to lock up all the drunks tonight."

That evening, some miner came in from his shift, jammed his candle holder in the wall with the candle still burning and hurried off to the saloons. A fire started in his room and quickly spread through the wooden-frame buildings in the business district. Volunteer firefighters from clubs with colorful names like Dudes and Toughs fought valiantly through the night.

Sheriff Ruffner saved most of the town when he led a party of powder men into an area ahead of the fire and dynamited the structures, halting the fire.

Earlier that evening, as the fire spread toward the famous Palace Saloon, customers rose to the occasion, picked up the priceless back bar along with its contents and carried them across the street to safety. They also saved the piano. That night, as Prescott burned, the bartender continued to serve drinks, and the piano player played. The most requested song: "There'll Be a Hot Time in the Old Town Tonight."

They tell a story up in Yavapai County of a time when Ruffner was on the trail of some dangerous outlaw. He knew the man was a crack shot with a Winchester, but he needed somehow to get close enough to get the drop without arousing suspicion. So he took off his hat, tied a neckerchief around his head and then tied up his stirrups. Then he covered his saddle with a tarp to make it look like a pack. His deception complete, he ambled toward the outlaw's camp, pretending to be a lonely old sheepherder leading his packhorse. The scheme worked beautifully, as the unsuspecting bandit allowed him to walk right into camp. The rest was easy. Ruffner had the drop and made the arrest without incident.

Perhaps George's most sensational case was the pursuit and capture of Fleming (Jim) Parker. Fleming Parker was a small-time cattle rustler and horse thief up around Peach Springs who was more of a nuisance to local ranchers than a real outlaw. He might never have been known outside his neighborhood if one day he hadn't decided to rob a Santa Fe train.

He was born in Visalia, California, in 1865. He lost his mother at an early age, and his father went insane when the boy was only fourteen. A year later, he was in trouble with the law and sentenced to a year and a half in San Quentin. No sooner was he out of prison than he got crosswise with the law again and decided to head for Arizona.

Parker hired out punching cows at the Thornton Ranch in Yavapai County near the headwaters of the Agua Fria River. He was only seventeen at the time but was rawhide tough and could cowboy with the best of them. He stood about five feet, eight inches; weighed about 160 pounds; and had brown, curly hair. He liked to wear his hat pushed back on his head. He had the recklessness of youth, his main interests being the saloons on Whiskey Row and the shady ladies over on Granite Creek.

Parker had been working for George Thornton about a year when twenty-year-old George Ruffner hired out for the outfit. Ruffner had been working for his uncle Andy as a miner, but he was a quick study and learned cowpunching quickly. Parker taught him to ride and rope, the two most

important things a cowboy needed to know. After about six months, they drifted around Yavapai County, working at various cow ranches.

In 1881, after the spring roundup at a ranch in Chino Valley, the boys drew their pay and headed for Prescott's bibulous Babylon, Whiskey Row. Parker was a devil-may-care cowboy looking for action, and Prescott had plenty. Ruffner was more interested in trying his luck at the gaming tables, and he was looking for a place to plant roots. The carefree life of a cowboy was all right for a youngster, but sooner or later a man had to get a stake. Their arrival in Prescott brought a turning point in their lives. Fate would lead these two cowhands down different *paseos*. George Ruffner would establish roots and call Prescott home for the rest of his life. Wild and wooly, Fleming Parker would continue to backslide toward his terrible end.

Prescott in those days was a bustling town. It was the territorial capital, and the mines in nearby mountains were booming. The railroad wouldn't arrive until 1887, so there was lots of money being made hauling freight. Supplies came into Prescott by freight wagons hauling from Colorado River ports at Hardyville and Ehrenberg. Other freight lines hauled through Yeager Canyon into Jerome and the Verde Valley. Also there was freighting to that upstart community in the Salt River Valley called Phoenix, one hundred miles to the south. So George decided to go into the freight business. Fleming Parker preferred the carefree life of a cowboy. As soon as his bankroll was spent, he'd hire out again until he had enough to come into town for another lengthy "whizzer."

Their lives continued to grow in different directions. George married Molly Birchett and, through hard work and perseverance, saw his business grow successfully. Pretty soon he added a livery stable and stage line to his business portfolio. Parker, on the other hand, continued his wild and reckless ways. Soon he drifted back into California and got in trouble with the law. In 1890, he was sent up for six years at San Quentin. He was released early and by 1895 was back in Arizona. This time he hired out for Hog-Eye Miller at the Hat Ranch near Williams. A year before his return, George Ruffner was elected sheriff of Yavapai County.

Not long after Parker went to work for the Hat Ranch, cattle began to turn up missing. Then he took a job breaking horses for the local constable at Williams, and pretty soon some of them were missing too. No one suspected Fleming Parker at the time. Then he drifted over to Seligman in Yavapai County. It was more than a coincidence that wherever he turned up, cattle and horses turned up missing. Not surprisingly, a short time after his arrival in Seligman, two rustlers were seen driving forty head of horses from a

holding pen. They drove them northwest up Aubrey Valley. Sheriff Ruffner and a posse were soon hot on the trail. The lawmen rode the train on the Bullock line from Prescott to Seligman and then mounted up and took out after the rustlers on horseback. They caught up with them near Frazier's Well and, in a running gunfight, recovered the horses. The two outlaws got away, but lawmen were pretty sure one of them was Fleming Parker.

Parker's next haunt was Peach Springs, where he joined up with Abe Thompson, Windy Wilson and Pug Marvin, an obstreperous band of rascals known as the Thompson Gang. Their activities included rustling livestock from ranches in that part of Arizona. The stolen animals were usually driven up Big Chino, past Seligman and west to Robber's Roost Canyon and then on to where Diamond Creek joins the Colorado River. They crossed the river and headed them up to Nevada, where they would be sold. The gang didn't play favorites. They pilfered livestock in Nevada and brought them back to Arizona for sale. They generally preferred stealing horses to cows because they could be moved at a much faster pace. Parker was a natural leader, and it wasn't long before he was making the decisions. The outlaws holed up in the protective confines of the rugged, steep-sided canyons at Robber's Roost Canyon, north of Peach Springs.

Train robbery offered a new dimension to the gang's activities. Wells Fargo was known to ship thousands of dollars in gold by rail.

Despite the fact that most of the train robbers were eventually apprehended, Fleming Parker decided to rob a Santa Fe train as it made its run through northern Arizona.

Parker studied all the operations of the trains and even learned the basics of running a locomotive. Then he laid out a plan. A large gold shipment was en route from San Francisco and soon would be passing through northern Arizona on the Santa Fe. The heist was set to take place on February 8, 1897. Parker and one other gang member would rob the train as it passed through Rock Cut between Peach Springs and Nelson. He made a big show of going into town and catching a train for California after telling everyone within earshot a good job was waiting. Then he caught another train at Barstow and circled up and around into Nevada. He then rode horseback south to the hideout at Rustler's Roost Canyon. Meanwhile, the rest of the gang, except for Windy Wilson, rode into Peach Springs to establish an alibi.

Everything went according to plan up to a point before Murphy's Law took over. Parker and Wilson jumped onto the train as it slowed on the grade at Rock Cut. Parker climbed into the cab and leveled his revolver at the engineer, who brought the engine to a halt. Wilson rushed back to

separate the express car from the mail car, not realizing the two cars had been switched.

When the train stopped, Wells Fargo messenger Jim Summers became suspicious and stepped down from the train with his pistol drawn. As he was walking toward the front of the train, he spotted Wilson unhooking the mail car. Windy looked up and jerked his six-gun, but the Wells Fargo man had the drop. Two shots rang out and Wilson went down.

Up on the engine, Parker heard two gunshots and thought it was the prearranged signal that the cars were separated so he ordered the engineer to move on down the line. It wasn't until they came to a halt where the horses were picketed that Parker realized Wilson was missing. Then he saw the mail car had been switched. Making the best of a bad situation, he rifled through the mail pouches and, in his haste, missed several thousand dollars in negotiable bonds. The disgusted outlaw then slipped away in the dark with a net gain of five dollars for his night's toil.

After the robbery, Parker headed for his lair at Rustler's Roost Canyon. A posse led by George Ruffner was formed in Prescott and rode by rail on the Bullock Line to Seligman and then on the Santa Fe to Rock Cut, where they unloaded their horses from the stock car and picked up the trail. Parker, knowing a posse was on his tail, tried to confuse them by cutting back, crisscrossing and circling around his pursuers. After nearly a week, the posse was able to get close enough to get Parker in their rifle sights. But he was on a rested animal and the lawmen's horses were trail weary. He escaped the hail of fire.

Anticipating pursuit, Parker had cached food and supplies at strategic places in the rough country near the Colorado River. Still the posse continued its dogged pursuit.

The lawmen finally rode Parker into the ground on February 22, north of Peach Springs where Diamond Creek empties into the Colorado River. Actually, it was a stroke of luck. Two members of the posse, One-Eye Riley and Martin Buggeln, were out gathering firewood when they accidentally stumbled upon Parker's camp. The outlaw, caught unaware and looking down the barrels of two six-guns, surrendered without a fight.

Fleming Parker likely would have gotten a light jail sentence for his crime. He was personable and had many friends in Yavapai County. A jury would surely have a few friends on it. But on May 9, 1897, he and two other prisoners made a daring break from the county jail. Parker, Lewis Miller and Cornella Sarata overpowered the guard and broke from their cells. On the way out, Parker grabbed a sawed-off shotgun.

Sheriff Ruffner's famous white horse, "Sureshot." Horse thief Fleming Parker swiped Sureshot from Ruffner's stable after escaping from jail in Prescott. *Courtesy of Southwest Studies Archives.*

Lee Norris, deputy county attorney, overheard the commotion and came to investigate. He opened the door just as the three escapees were making their bid for freedom. Too late, Norris tried to turn and head back through the door but was cut down with a load of buckshot. He would die later that night.

The three fugitives headed for George Ruffner's livery stable. Parker, always the judge of good horseflesh, chose Sureshot, the sheriff's best horse and reputed to be the fastest horse in the territory. Sureshot was a long-legged, white horse Ruffner had gotten from the Hash Knife Ranch. He was part Arab, had great endurance and could run like the wind.

They hightailed it out of town, going south at first and then cutting back north toward Point of Rocks (Granite Dells), thence southeast toward Lynx Creek.

George Ruffner was in Congress when word of the jailbreak reached him. He commandeered a locomotive and rushed back to Prescott in time to join the posse at Point of Rocks.

The posse caught up with the escapees at Lynx Creek. Deputies opened fire and shot Miller's horse out from under him. Miller also took a bullet in the side and another in the leg. Parker pulled the wounded man up on the

back of Sureshot, and the two escaped in a hail of gunfire on the great white horse. During the flight, Parker was hit in the leg. The outlaws were unable to return fire, as the only weapon they had was the shotgun taken from the jail, and it was useless at that range. Sarata and Miller had both stolen Winchesters at the livery stable but lost them then in the chase. It was later claimed the deputies were firing high because none wanted to take a chance on shooting the sheriff's favorite horse.

The third escapee, Cornella Sarata, was never seen again. He, too, was shot in the leg. Some claimed he left the others and headed for Crown King, where he had relatives who would smuggle him back to Mexico. Others insisted he crawled off in some hidden place and died of his wounds.

Parker and Miller, riding double on Sureshot, headed southeast toward the Agua Fria River. Somewhere along the way, the two decided to split up, as Miller's wounds were giving him considerable pain. Parker kept riding southeast, and Miller headed north for Jerome Junction (Chino Valley) on foot. At the junction, Miller followed the narrow-gauge railroad tracks east several miles to Jerome, where a sister lived. For a couple of days, he hid out in the appropriately named Deception Gulch. Finally he was able to make contact with his sister, and she persuaded him to surrender to authorities. Jerome constable Jim Roberts of Pleasant Valley War fame and two other lawmen then took Lewis into custody and escorted him to the Coconino County jail at Flagstaff.

Meantime, Parker turned north, again cleverly concealing his trail by crossing and recrossing. Using bloodhounds, the posse picked up his trail at Pointed Rocks but quickly lost it again, causing the local newspaper to quip, "The fox is smarter than the hounds."

Ruffner stubbornly kept up pursuit. A note was found pinned to a post offering a $1,000 reward for the sheriff, "dead or alive—dead preferred."

Sympathetic cowboys who'd known or ridden with Parker threatened to shoot up the pursuers and their bloodhounds. The man who owned the bloodhounds became discouraged when someone stole his horses and wanted to quit the chase. Then Parker left a note offering to pay a ten-dollar reward for every bloodhound that was shot. That was the last straw. He took his beloved dogs and returned to Phoenix.

Parker rode into a sheepherder's camp and swapped the shotgun for a Winchester. The wily fugitive also threw a lost treasure map in on the deal. He told the herder he'd buried $1,500, taken in the robbery, in a can and said it was his for the taking. The grateful sheepherder then drove his flock over Parker's tracks and sent the posse on a wild goose chase.

When another herd of sheep wiped out a trail, Ruffner returned to Prescott to await further leads. The rumor mill began churning out sightings. It seemed the elusive Parker was everywhere and nowhere at the same time.

Still believing the posse was on his trail, Parker reshod Sureshot, put the shoes on backward and rode him some distance. Near Williams, he turned the white horse loose and stole another good horse from a rancher he used to work for. Then he rode into Williams and left his ex-boss's horse at a livery stable and stole another. This time he wrapped burlap around the animal's feet and rode west at a gallop. Still no one seemed to know the whereabouts of Fleming Parker. Lawmen believed the locals were sympathetic to the gregarious cowboy, as many knew him from when he worked for ranches in the area years before.

At the time lawmen were scouring the town, Parker was hiding out in a little cave in the mountains west of Williams. While at the cave, Parker was left afoot when his latest equine acquisition got loose and returned to the safe confines of the livery stable.

Lawmen got a break when someone spotted Parker walking near Hog-Eye Miller's Hat Ranch a few miles west of Williams. Bloodhounds were brought in again and followed the scent right to the ranch house, but by this time Parker was gone again. The trail led up into the rough, lofty reaches of Bill Williams Mountain. They found a cave and warm coals showing the outlaw was close, but the dogs got to sneezing and lost the trail. This time the foxy fugitive had spread pepper on his trail. Once again, Parker had outwitted his pursuers. The frustrated lawmen went home to await further developments. Meanwhile, Parker, riding a horse given to him by Hog-Eye, was riding north into Navajo land.

The next break came on May 23, when two Navajos saw Parker's picture on a wanted poster at a trading post north of Tuba City. They'd seen the fugitive crossing the Little Colorado River near Cameron. Navajos in the area kept Parker under surveillance while lawmen in Flagstaff and Prescott were alerted. Soon, Sheriff Ruffner was hot on the trail again, this time in the arid desert north of the Little Colorado River. Thanks to the expert work of the Navajos keeping tabs on Parker's itinerary, lawmen from Coconino County were able to sneak up on his camp about sixty miles north of Tuba City and take him without a fight. He awoke to see several rifles pointed in his direction.

"Mornin' Parker," Coconino sheriff Ralph Cameron said.

"Reckon it ain't so good for me," Parker mused.

Sheriff Ruffner arrived in time to meet the lawmen from Coconino County at a crossing on the Little Colorado.

Parker is supposed to have said to Ruffner, "Where in hell would I have to go to find a place where you wouldn't be?"

And the trail-weary sheriff is supposed to have replied, "That's exactly where you'll be when I finish ridin' herd on you."

Parker later said he'd planned to make another escape while they were fording the river by jerking a pistol from the holster of one of the Navajos and getting the drop on the others but gave up on the idea when Ruffner arrived.

Fleming Parker was then taken back to Flagstaff and placed in a cell next to his accomplice, Lew Miller. Before leaving for Prescott by train, a blacksmith riveted leg irons on both prisoners.

The train passed through Williams without incident and later that evening pulled into Ash Fork, where they changed trains and climbed aboard the Santa Fe Prescott and Phoenix Railroad for Prescott.

Rumors of a lynch mob in Prescott had Ruffner uneasy so he made plans to avoid a confrontation. As the train rolled quietly into Fort Whipple, just outside Prescott, late that night with its headlight off, a carriage was waiting to deliver the prisoners the rest of the way. It wouldn't have mattered, as the expected crowd wasn't at the station but were waiting at the courthouse. There were a few tense moments. Miller feared they were going to get lynched, but Parker chastised him, saying, "Have a little courage—they can only hang you once."

Ruffner wasn't in the mood for macho-talking townies. If the crowd had any plans for a necktie party, he quickly laid them to rest with some tough talk. The citizens were gruffly told to go home, and the prisoners were returned to the scene of their escape three weeks earlier.

Parker went on trial on June 15, 1897, before Judge John Hawkins for the murder of Lee Norris. The trial lasted three days and returned a guilty verdict. A few days later, Judge Hawkins sentenced him to hang the following August 13. Miller, for his part, was given a life sentence at the Yuma Territorial Prison. He served only a few years and was released.

In jail, Parker was reunited with his partner in crime, Abe Thompson, who was being held on suspicion of the train robbery. He was released but later pulled a one-man robbery of the Santa Fe line north of Prescott and was captured. His demise has two versions. One story has it a lawman caught up with him and brought his carcass in tied over the back of a horse.

Appeals and delays postponed Parker's execution until June 8, 1898. The law required a certain number of witnesses, and Sheriff Ruffner hadn't bothered to have invitations made for the hanging so he dealt cards

Sheriff George Ruffner, the tall man in the white shirt, had the unpleasant task of pulling the lever to hang his old friend Fleming Parker. *Courtesy of Southwest Studies Archives.*

to witnesses from his personal deck. No one was allowed into the hanging grounds without a card.

On Parker's last night in jail before his hanging, Ruffner asked if he could bring him anything. Parker replied he'd sure like to see Flossie, one of the good-time girls from the "district" over near Whiskey Row. So the sheriff sought out the lady in question and found her willing to fulfill Parker's last request. He sneaked Flossie in through the back door of the jail and locked her in Parker's cell. Later that night, he returned and escorted her back to the district.

On that final day, Parker, seeing daylight for the first time in a year, was led to the black-painted scaffold. He halted at the steps and asked if he could have a look around, as he'd never seen one before. His curiosity satisfied, he climbed the steps and surveyed the crowd. He saw an old friend and called, "Hello Jack, how are they breaking?"

Parker announced on the scaffold that there was only one man he respected enough to pull the lever at his hanging, and that was his old friend George Ruffner.

After his arms and legs were secured, Parker was asked if he had any last words. "I have not much to say," he offered, "I claim that I am getting something that ain't due me, but I guess every man who is about to be hanged says the same thing so that don't cut no figure; whenever the people says I must go, I am the one who can go and make no kick."

As they started to place a black cover over his head, Parker asked to shake hands with the boys on the scaffold and then said to the jailer, "Tell the boys I died game and like a man."

At exactly 10:31 a.m., Sheriff Ruffner pulled the lever, and his old friend-turned-adversary dropped six feet—to eternity. At 4:00 p.m. that afternoon, Fleming Parker was buried in a potter's plot in the cemetery. The act of hanging a man sickened Ruffner enough that he pressed to have future hangings take place at the territorial prison. Parker's was Prescott's last hanging.

It was a real twist of the tale at the end, sounding very much like a plot dreamed up in Hollywood. The story begins with two young cowboys who met a fork in the road. One took the outlaw trail; the other became a lawman. One died at the end of a rope; the other had to pull the lever.

George Ruffner had a long and illustrious career as a lawman in Yavapai County, and when he died in 1933, he was the state's oldest sheriff in age and seniority. Many years later, he became the first Arizonan inducted into the National Cowboy Hall of Fame in Oklahoma City.

Sureshot, the long-legged white horse, spent his last years in Phoenix on a small farm located at the site of the famous Biltmore Hotel. According to historian Budge Ruffner, the sheriff's nephew, Sureshot was the only member of the Ruffner family be buried at a five-star resort.

8

BURT MOSSMAN

CAPTAIN OF THE ARIZONA RANGERS

Around 1900, while the territory strove for statehood, vicious bands of outlaws sullied Arizona's reputation. One measure meant to whip the bandits and to further statehood efforts was the formation of the Arizona Rangers. Their first leader was an Illinois native who began working as a cowhand when he was only fifteen years old.

Arizona greeted the twentieth century as a frontier Jekyll and Hyde. On one hand, communities like Phoenix, Prescott and Tucson were becoming modern cities. Churches and schools outnumbered the bawdy houses and saloons, a sure sign that civilization was making progress. Law and order generally prevailed. In 1907, both gambling and prostitution were outlawed.

On the other hand, the rural, mountainous regions still provided a refuge for desperadoes. Large bands of outlaws holed up in the primitive wilderness of the White Mountains. Mexico was a sanctuary for border bandits. Arizona was the last of the wild places. Outlaws on the run in other territories and states could find a safe haven in the labyrinth of canyons and brooding mountains. Towns were few and far between, and roads were mostly cattle trails.

With the completion of the Santa Fe line in the north and the Southern Pacific in the south, stage robbers turned to a new line of work. Between 1897 and 1900, there were six train robberies on the Southern Pacific alone. Bands of rustlers boldly stole cattle in broad daylight, driving small outfits out of business. Payrolls for the mines were being robbed on a regular basis.

County sheriffs had no jurisdiction outside their districts. Once an outlaw crossed a county line, he was home free. During the 1880s, there was a large outcry from ranching and mining interests for a territorial police modeled after the famous Texas Rangers. By the turn of the century, politicians were trying to impress upon the U.S. Congress the fact that Arizona was ready for statehood. Many in Congress didn't think the Arizonans should be admitted until they did something about the lawlessness.

In March 1901, the territorial legislature passed a bill to raise a quasi-military company of rangers who not only could shoot straight and fast but also ride hard and long. Funding for the ranger force would come from a territory-wide tax.

The force would consist of fourteen men, including a captain and a sergeant. The term of enlistment was for one year; the captain would receive $125.00 a month, the sergeant was paid $75.00 and the twelve privates would each be paid $55.00 a month. Rangers had to provide their own horses, tack and weapons. With typical generosity, the politicians also allowed each ranger $1.50 a day to feed both him and his horse.

On March 19, 1903, rangers were expanded to twenty-six men. The captain's pay was raised to $175 a month, a lieutenant was added and received $130, two sergeants at $110 and twenty-two privates at $100 a

The hard-riding Arizona Rangers were "darlings of the press," and this is one of their better-known photographs of the Wilcox patrol. *Courtesy of Southwest Studies Archives.*

month. Officially, the rangers' duties were to assist local law enforcement agencies, prevent train robberies and run the rustlers out of the territory.

They were placed under the command of the governor, and this created problems from the beginning. Territorial governors were appointed in Washington, while legislators were elected locally. Most governors were Republicans, while the Democrats always controlled the legislature. Many in the legislature saw the rangers as the governor's private police force. Another problem that plagued the rangers from the beginning was most of the outlaws were operating in the rugged mountains of eastern Arizona or along the Mexican border.

Other counties, such as the populous Maricopa County, had little need for the free-ranging lawmen and resented having to share the tax burden. There was also some professional jealousy. The activities of the colorful rangers were closely followed by an adoring press. Local lawmen, who shared the same dangers while rounding up desperadoes, found themselves being left out of the newspaper stories, and they naturally felt resentful.

Still another problem the rangers would face during their tenure was image. They were a rough-and-ready bunch, and they had to be as tough as the desperate men they pursued. Consequently, some got into scrapes that sometimes went beyond their duties as lawmen and brought bad publicity to the entire force. If the rangers were going to be effective, they would need a captain who could lead and hold the respect of his young hellions.

Burt Mossman was Governor Nathan Oakes

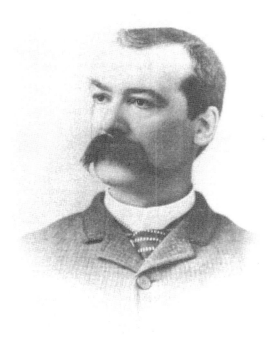

Captain Burton C. Mossman was the first captain of the Arizona Rangers. His last adventure during his tenure was the daring capture of the notorious Augustine Chacon. *Courtesy of Southwest Studies Archives.*

Murphy's choice to be captain of the Arizona Rangers. The rawhide-tough cowman had made quite a reputation for himself when he ran the famous Hash Knife outfit in northern Arizona.

Mossman's life reads like something out of a Louis L'Amour novel. He was the son of a Civil War hero, a descendant of Scots-Irish ancestry, that adventuresome breed who carved out a niche of history on the American frontier a century earlier. He stood five feet, eight inches, weighed 180 pounds and was of stocky build, with broad shoulders. By the time he was fifteen, Mossman was drawing pay as a working cowboy in New Mexico.

As a young cowboy, Mossman earned a reputation as a quick-tempered, wild and restless youth who'd fight at the drop of a hat. He was also very dependable and honest, something that earned the respect of the ranchers

Prior to becoming captain of the Arizona Rangers, Mossman was superintendent of the famous Aztec Land and Cattle Company, better known as the Hash Knife Outfit. *Courtesy of Southwest Studies Archives.*

for whom he worked. Once he walked 110 miles across a dry, burning desert to deliver an important letter for his boss. He walked the forty-seven-hour journey because he thought the land was too dry for a horse to travel.

By the time he was twenty-one, Mossman was foreman of a large ranch in New Mexico that ran eight thousand head of cattle. At twenty-seven, he was managing a big outfit in the Bloody Basin in Arizona's rugged central mountains. Three years later, he was named superintendent for the troubled Aztec Land and Cattle Company, better known as the Hash Knife Outfit. The fabled Hash Knife had been one of the biggest cow outfits in the West. But now it was on the verge of bankruptcy when he was called in to try and keep it from going belly up.

It was while running the Hash Knife that Burt Mossman achieved his greatest fame up to that time. The eastern-owned outfit had been running as many as sixty thousand head of beef over two million acres. Gangs of rustlers, both in the employ of the company and those who set up maverick factories on the fringe, had been stealing the ranch blind. The ranch had been frustrated in its attempts to stop the rustling by locals who resented large, absentee ownership and who, because of land grant advantages, were able to graze their cattle free on the public domain. Consequently, local juries were prone to find defendants not guilty. Also the rustlers were able to get friends on the jury to disrupt things, causing a mistrial or hung jury. In fourteen years of trying, the Hash Knife hadn't been able to get a single conviction.

Mossman didn't waste time settling into his new job. On his first day, the scrappy cowman captured three rustlers and tweaked the nose of Winslow's town bully. Then he fired fifty-two of the eighty-four cowboys on the Hash Knife payroll and installed trusted cowmen as wagon bosses. He visited local leaders in the community and convinced them to take a stand against cattle rustlers. Soon, he had the outfit turning a profit again.

But Mossman couldn't control the weather, the cowman's greatest nemesis. A prolonged drought, followed by a calamitous blizzard, finished off the company in 1901.

Despite the failure of the Hash Knife, Mossman earned a reputation as a formidable foe of cattle rustlers, along with being a smart, savvy businessman. After the Hash Knife, he headed for Bisbee, where he opened a beef market with Ed Tovrea, but he didn't stay in that business long. When the Arizona Rangers were organized, Governor Murphy knew it would take a special kind of man to manage more than a dozen energetic, high-spirited lawmen, and Mossman was that man.

Mossman agreed to a one-year enlistment, and though his tenure was brief, the rangers had some of their greatest success during that first year. He located the ranger headquarters in Bisbee and set about recruiting his force. It wasn't hard. Every young man in the territory with a spirit of adventure wanted to ride with Mossman's rangers. He selected his men carefully, dressed them as working cowboys and had them hire out for outfits where rustling had been a problem. They operated in secrecy as undercover agents infiltrating cliques of rustlers. They kept their badges concealed and pinned them only when an arrest was imminent.

The rangers met their greatest challenge early on when they took on a band of wild marauders known as the Bill Smith Gang. The outlaws had been run out of New Mexico and set up new operations at Smith's widowed mother's place near Harpers Mill on the Blue River.

Taking on Bill Smith and his band of renegades was a sad and disappointing experience for the new force. Bill Smith gunned down ranger Carlos Tafolla and Apache County deputy sheriff Bill Maxwell near the headwaters of the Black River in eastern Arizona. Mossman was determined to run the gang into the ground and made a gallant pursuit all the way to the Rio Grande but never got his man. The only satisfaction he got was the gang was driven out of Arizona for good.

Next, the rangers invaded the den of another band of cow thieves, the Musgrave Gang, led by George Musgrave and his brother, Canley. They were wanted in Texas and New Mexico for robbery and murder. The Musgraves had also ridden with the Black Jack Gang, a tempestuous band of highwaymen that had ravaged along the Arizona–New Mexico border country.

The successful raid on the outlaw band came after lawmen learned that one of the gang, Witt Neill, had a girlfriend living up on the Blue River. Then deputy sheriff John Parks received a tip that several well-armed, suspicious-looking men were seen at the mouth of the Blue River, north of Clifton. He passed the information on to Graham County sheriff Jim Parks at Solomonville and to Captain Mossman at Bisbee. Parks and Mossman rushed to Clifton and organized a posse to go after the marauders. They headed for the girlfriend's place. Arriving late at night, the lawmen surrounded the cabin and waited for dawn. At first light, they closed in and found Neill sleeping on the porch. He awoke looking into the muzzles of several pistols and rifles. The rustler had a Winchester, a pair of six-guns and enough bullets to start a revolution tucked under the covers but wisely surrendered without a fight.

Two other members of the gang, George Cook and Joe Roberts, were spotted that same day driving some stolen horses. The posse split up and surrounded the men without being spotted. The unwary rustlers were apprehended and then hustled off to the jail at Solomonville. The pair was believed to have robbed a store in New Mexico, murdering the owner. Cook and Roberts also fit the description of two men who robbed a post office at Fort Sumner the previous January.

With the capture of one of the *segundos*, or leaders, and a couple of others, the Musgrave leadership was shattered and scattered, causing the gang to quit the country.

The spirit of cooperation between the rangers and the Mexican police was generally good. The Mexican forces, called Rurales, were the rangers' counterparts. They were ably led by Colonel Emilio Kosterlitzky, one of the more remarkable men in the border country. A Russian by birth, he spoke several languages fluently and was a man of great intellect. Kosterlitzky came to Mexico as a young man and joined the ranks of the Rurales as a private. He rose to the rank of colonel in President Diaz's feared police. A stern, no-nonsense commander, his men operated under the law of *ley fugar*, or "law of flight." In other words, they brought in few live prisoners. The common practice was to say the captive was "shot while trying to escape." It was a brutal but effective way of lowering the population of the border bandits.

The rangers and Kosterlitzky didn't bother with the formalities of diplomatic red tape when dealing with fugitives. Kosterlitzky had appointed the rangers officers in his force. They often crossed the border into Mexico in pursuit of some outlaw, and fugitives were frequently exchanged quietly between the two groups. A wanted man in Arizona might be sitting in a cantina in Cananea thinking he was in a safe haven. He might go upstairs with some pretty *señorita* to have a nightcap, and the next thing he knew, he was sitting in the jail in Bisbee wondering how he got there. The young lady was working with the rangers. She'd slipped him a mickey and handed him over to the Rurales, who, in turn, hauled him to the border with a gunnysack over his head and turned him over to the rangers. Mossman learned early on that the best source of information came from the ambitious saloon girls in the border towns.

Near the end of Mossman's enlistment as ranger captain, he was involved in a fracas one night at the Orient Saloon in Bisbee. He and ranger Bert Grover were sitting in a poker game with some $400 in the pot, which was won by a local gambler. Grover accused the gambler of cheating and jerked

his six-shooter. Mossman tried to calm down his ranger just as a couple of Bisbee police arrived. When the police arrested Grover, Mossman and another ranger, Leonard Page, joined in. The donnybrook wound up in the street in front of the Orient, much to the delight of the Saturday night revelers of Brewery Gulch. Grover was finally placed under arrest and taken to jail. A few hours later, the resourceful Page purloined the keys to the jail and freed his comrade.

The citizens of Bisbee were upset by the rangers' rowdy actions, and two hundred of them signed a petition demanding Governor Murphy relieve Mossman of his command. Most of those signing the petition, however, were barflies, tinhorns and other wretches with axes to grind who inhabited Brewery Gulch. A group of respectable citizens circulated another petition in support of Mossman.

A couple of days later, Mossman submitted his resignation to the governor. He hadn't planned to stay in the low-paying position long when he signed on, and with his good friend Governor Murphy leaving office, he, too, might have felt it was time to move on. Also he was a typical cowhand, free and independent, and the incident in Bisbee might have soured him on public service.

During Burt Mossman's tour of duty, the rangers put 125 men behind bars and, remarkably, considering the kinds of hard-bitten desperadoes they were dealing with, killed only one man. One ranger, Carlos Tafolla, was killed in the line of duty.

While Captain Mossman was waiting for his resignation to become effective, he needed to tie up some loose ends. During the past year, he'd become obsessed with capturing Augustine Chacon, one of the most cunning and rapacious outlaws in the border country. Chacon lived in Sonora but made periodic forays into Arizona to loot and pillage. The handsome *bandito* once boasted to an officer he'd killed thirty-seven Mexicans and fifteen Americans. He was looked upon in Sonora and among the Mexicans working in the mining camps of Arizona as a folk hero because he'd given the *gringo* lawmen such fits. But in reality, he was a diabolical killer. During the robbery of a store in Morenci on Christmas Eve 1895, he slit the throat of the shopkeeper with a hunting knife. A posse cornered him and tried to negotiate a surrender. During the parley, he shot posse man Pablo Salcito in cold blood. Salcito, who was acquainted with the outlaw, had tied a white handkerchief to the barrel of his rifle and had walked to within a few feet of Chacon when the outlaw gunned him down. In the ensuing gun battle, Chacon was wounded and captured. A Graham County jury convicted and sentenced him to hang.

Chacon escaped the hangman's noose in Solomonville by breaking out of jail nine months before his sentence was to be carried out. The roguish bandito had a string of pretty *señoritas* at his beck and call. His inamorata in Solomonville managed to slip him a file concealed in the spine of a Bible. A mariachi band was doing time in the jail for some transgression so Chacon had them play a cacophony of *corridos* to drown out the noise while he sawed through the bars. His pretty girlfriend had flirted with the jailer on several occasions and, on the night of his escape, persuaded the love-struck fellow to take her for a midnight stroll. The jailer returned later to find his prisoner had flown the coop. During his escape to Sonora, Chacon murdered two prospectors, and for the next five years, he managed to evade both Mexican and American lawmen.

Mossman made up his mind that the capture of Augustine Chacon would be his crowning glory as ranger captain. He concocted a daring plan to slip into Sonora, posing as an outlaw on the run, and gain the wily outlaw's confidence long enough to take him prisoner. But he would need some accomplices. He found them in two homesick *gringo* fugitives, Burt Alvord and Billy Stiles.

Alvord had been a constable, and Willcox was formerly a deputy

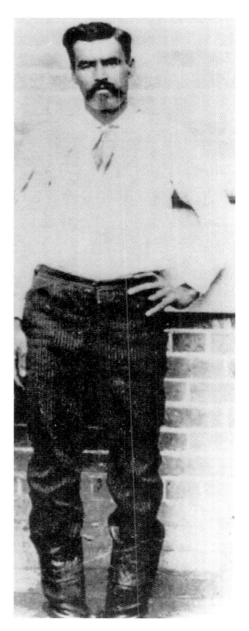

During the 1890s, one of Arizona's most notorious outlaws, Augustine Chacon, terrorized citizens on both sides of the border. *Courtesy of Southwest Studies Archives.*

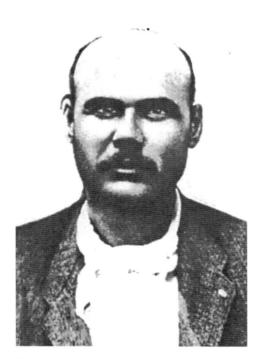

Burt Alvord was the dull-minded constable of Willcox who masterminded two train robberies in Cochise County. The second one put him behind bars. *Courtesy of Southwest Studies Archives.*

to Cochise County sheriff John Slaughter. His major interests were poker, pool, guns and practical jokes before he decided to do some moonlighting on the side by robbing a train. Burt wasn't the sharpest knife in the drawer so he figured he'd never be suspected of masterminding a heist or two. His gang of rascals included "Three-Finger Jack" Dunlap, "Bravo Juan" Yoas, Bill Downing and Billy Stiles.

The Alvord gang succeeded admirably on its first job, robbing the Southern Pacific near Cochise on September 11, 1899, and got away with some $3,000.

Local lawman Bert Grover, who would later serve in the rangers, suspected Alvord but didn't have enough solid evidence to make an arrest.

Caught up in its success, the gang tried to rob another train, this time at the train station in Fairbank on February 15, 1900. The outlaws didn't figure on former Texas Ranger Jeff Milton riding shotgun that day. When the smoke cleared, the outlaws rode away empty-handed. Bravo Juan had a load of buckshot in his rear, and Three-Finger Jack was mortally wounded. The outlaws abandoned Jack along the trail, and when the posse caught up, he gave a deathbed confession.

Alvord and his gang were locked up in the county jail in Tombstone. One of the bandits, Billy Stiles, offered to testify against his cohorts and was released from custody. A few days later, he broke into the jail and freed his friends. Alvord and his friends then high-tailed it for Sonora.

Two years later, Burt Mossman heard that Alvord and Stiles wanted to come home. In January 1902, he got word to the fugitives that if they would help him capture Chacon, they could share the reward money and he'd testify in court to their good character. He even went so far as to put Billy

Stiles on the payroll as a ranger. Alvord's wife was threatening to divorce him if he didn't come home soon. That gave Mossman some added leverage.

Apparently, Colonel Kosterlitzky knew of Mossman's plans to make the illegal capture of a Mexican citizen but had no plans to interfere as long as the ranger didn't create a situation that would force him to get involved. He, too, wanted Chacon brought to justice.

Burt Mossman rode into Mexico in April 1902, posing as a fugitive. He learned Alvord was holed up west of the village of San Jose de Pima. Two days later, he met up with Alford at his hideout. The hilltop adobe house was a veritable fortress with loopholes, battle shutters on the doors and windows and a commanding view of the surrounding terrain. Inside one of the rooms, horses were saddled and ready to ride out at a moment's notice.

Alvord spent some time thinking about Mossman's offer. He missed his wife and wanted to go home but didn't want to betray Chacon. Finally, he agreed to cooperate and set up Chacon so the ranger could make the capture. Mossman then rode north to await word from Alvord on where he could meet Chacon. Billy Stiles would be the messenger.

Several months later, in late August 1902, Billy Stiles brought word that he, Mossman and Alvord would meet Chacon at a spring sixteen miles south of the border on the first day of September. To entice Chacon out into the open, they offered to cut him in on a plan to steal some prize horses from a ranch a few miles north of the border in the San Rafael Valley.

Mossman and Stiles rode to the spring on September 1, but Alvord and Chacon failed to show. They rode back across the border to spend the night and then returned the next day. Around sunset the following day they met the two outlaws on the trail. Both were heavily armed. Along with his rifle and pistol, Chacon was packing a large knife. Despite assurances by Mossman, claiming that he, too, was a fugitive, the cagy bandit was suspicious. His hand was never far from the butt of his six-gun.

That night they made camp, and Mossman nervously waited out the sleepless hours, his coat pulled up, concealing his face. Beneath the coat, his pistol was trained on Chacon. The ever-vigilant Chacon never let his guard down either. He refused to let any of the men get behind him. To make matters worse, Mossman wasn't sure he could trust either Alvord or Stiles not to betray him.

At daybreak, the men got up and started a fire. While Chacon was fixing breakfast, Alvord slipped next to Mossman and quietly said he'd done his part and was heading out. He also warned the ranger not to trust Billy Stiles. Then he told Chacon he was going for water and would return shortly.

While the three men were eating, Chacon's eyes narrowed and he wondered suspiciously what was taking Alvord so long to return.

After breakfast, Chacon reached in his pocket and took out some corn husk cigarettes and offered them to Stiles and Mossman. As they hunkered down around the fire having a smoke, Mossman saw his chance. He let his cigarette go out and then reached into the fire with his right hand, picked up a burning stick and relit his cigarette. As he reached out and tossed the stick back into the fire, Mossman's hand slid past his holster. Quick as a flash, the ranger pulled his revolver and got the drop on the surprised bandit. He ordered Chacon to put his hands up. The outlaw cursed but did as he was told. Next, the ranger told Stiles to remove Chacon's knife and gun belt. And to Billy's surprise, told him to drop his gun belt also. He then ordered both men to step back while he gathered in the rifles and pistols. After ordering Stiles to handcuff Chacon, the trio mounted up and rode for the border.

Mossman decided to avoid Naco, fearing Chacon might have friends there. Instead, he headed across the San Pedro Valley about ten miles west. Stiles rode in front, leading Chacon's horse, while Mossman covered them both from the rear with his Winchester. As they neared the border, Chacon began to balk. So Mossman unstrapped his riata and dropped a loop around his neck, warning that he would drag him across the border if necessary. The outlaw cursed again but caused no more trouble.

They arrived at Packard Station on the El Paso and Southwestern Railroad line just as the train to Benson was passing through. Mossman's luck was holding. He flagged it down, and they made the final fifty miles to Benson riding the steel rails. At Benson, they were met by Graham County sheriff Jim Parks, who was most eager to take Chacon back to the jail at Solomonville he'd escaped from five years earlier and his long-awaited rendezvous with the hangman.

Word spread quickly of Mossman's daring capture of the outlaw Chacon and caused a lot of excitement around territory. A few eyebrows were raised when it was pointed out that his ranger commission had expired four days before he captured Chacon and he'd arrested the bandit on foreign soil. The Mexican government expressed outrage at the flagrant violation of their sovereign soil. Mossman stayed around Arizona just long enough to keep his promise to Billy Stiles. After testifying for Billy, he boarded a train and headed for New York City, where he was greeted royally by a grateful Colonel Bill Greene. He spent the next few weeks far removed from the political rumpus he'd created in Arizona.

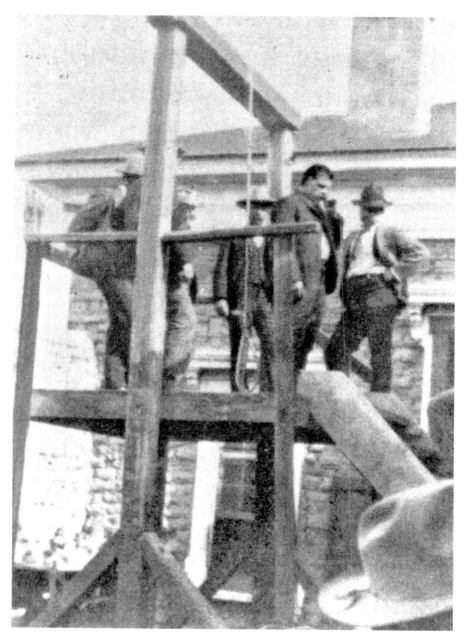

On November 23, 1902, Augustine Chacon was hanged in Solomonville, Arizona. *Courtesy of Southwest Studies Archives.*

At one o'clock on the afternoon of November 22, 1902, Augustine Chacon climbed the thirteen steps to the top of the scaffold and gave a thirty-minute speech that would have done a politician proud, closing with, "It's too late now; time to hang...*Adios todos amigos!*"

Thus ended the career of one of Arizona's most deadly and dangerous outlaws.

With the capture of Augustine Chacon, Burt Mossman closed out his brief career as a lawman in spectacular fashion. He went back to New Mexico, where he became a successful rancher. He died in Roswell, New Mexico, in 1956. A few years later, he was inducted into the National Cowboy Hall of Fame in Oklahoma City. Chiseled out of old granite, Captain Mossman was one of the truly great cattlemen and lawmen of the Old West.

9

PEARL HART

THE GIRL BANDIT

For most of her life, Pearl Hart lived in dismal obscurity. She got her chance for fifteen minutes of fame following a bungled stagecoach robbery in 1899. An adoring eastern press dubbed her the "Girl Bandit" and chastised the callused Arizona judicial system for putting such a pretty young lady behind bars in the notorious Yuma Territorial Prison.

Some accounts credit her with holding up the last stagecoach and also being the only woman to rob a stage. However, neither account is true. The last stage robbery took place in Nevada in 1916, and a woman named Jane Kirkham was killed while robbing a stagecoach near Leadville, Colorado, in 1879.

Not much is known about her early years. She was born Pearl Taylor of French descent in Lindsay, Ontario, Canada. She was five feet, two inches tall, weighed less than one hundred pounds, was reasonably intelligent and was considered quite attractive. It was said she came from a respectable, well-to-do family, but things started going downhill at age seventeen when she married a shiftless gambler named Frederick Hart.

They traveled in 1893 to Chicago, where Freddie hired out as a carnival barker at the Chicago Exposition and she worked at odd jobs. At the exposition, she got a chance to see Annie Oakley perform and became enthralled with the Wild West show. She was also an avid reader of the popular dime novel books, presumably on colorful characters like Belle Starr and Calamity Jane.

The Old West drew her like a moth to a flame, something that likely inspired her to dump her worthless husband and head west with an itinerant piano player.

In Trinidad, Colorado, she took a job as a saloon singer but had to return to her family when she learned she was expecting Freddie's baby. After giving birth to a son, Pearl left him with her family and headed for Phoenix. She worked at a series of unskilled jobs. Pearl soon found that life in the West wasn't as glamorous as those dime novels she'd read about and Wild West shows she'd seen at the exposition in Chicago.

Sometime in 1895, Freddie showed up in Phoenix begging her to take him back. She did, and for a time things were good between them. However, they began living it up in the saloons along Washington Street, where she developed a fondness for cigars, whiskey and morphine. A second child, this time a girl, was born, and their domestic problems resumed. Following an argument that got out of hand, he beat her up and then left town.

One version says he joined Teddy Roosevelt's Rough Riders and went to Cuba, but his name doesn't show up on the roster of either of the two Arizona companies.

Pearl returned to her family, left the baby with her mother and headed west again, taking up residence in various Arizona towns like Globe, Phoenix, Tucson and Tombstone and working at various times as a prostitute, waitress or cook.

She was working in a café in Mammoth when she took up with a miner, gambler and con man named Joe Boot. After a letter came from home saying her mother was ill and needed money, Joe decided the couple could make some easy money robbing a stagecoach. On May 30, 1899, near Kane Springs just north of the Gila River on the road from Florence to Globe, they held up the stage, taking some $400. Neither of the two knew the lay of the land and hadn't really planned an escape route. They headed up the San Pedro River toward Benson, where, on June 3, a posse caught up with them. Boot meekly surrendered, but Pearl gamely tried to put up a fight with all the strength her one hundred pounds could muster. The two were escorted to Florence and locked in the local jail.

The Florence jail had no facility for women so she was taken to Tucson to await trial. While temporarily residing in the Tucson jail, she used her feminine wiles on a couple of admiring gents to help her escape, but she was quickly recaptured in Deming, New Mexico, when a lawman recognized her.

During her trial, Pearl changed into a pretty dress and told the jury that she had robbed the stage to get enough money to visit her sick mother back east. She batted her eyes, lifted her skirt to reveal a well-shaped ankle and flirted shamelessly with the all-male jury. Naturally, they found her not guilty.

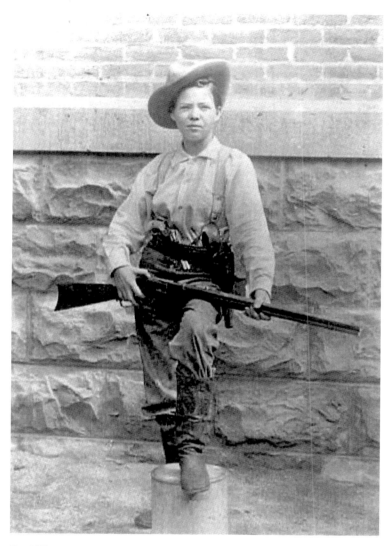

Pearl Hart posing for the photographers in her stage-robber attire. Presumably the rifle wasn't loaded. *Courtesy of Southwest Studies Archives.*

Judge Fletcher Doan was outraged and ordered her to be tried again, this time on a federal charge for tampering with the male...er...mail.

Newspapers, especially the Hearst press, turned her into a national celebrity. People gathered around to see the famous girl bandit. She enjoyed playing the role of a desperado, signing autographs and flirting with the men.

Pearl Hart as she demurely dressed to catch the eye of the all-male jury during her trial for robbing a stagecoach. *Courtesy of Southwest Studies Archives.*

Pearl and Joe were tried and convicted. She was sentenced to five years in the Yuma Territorial Prison. Her accomplice was given thirty years on the same charge. Being a female in the Old West did have some advantages.

Pearl briefly enjoyed her celebrity status at the prison. Visitors and reporters were allowed to visit. She was paroled on December 15, 1902, and told to get as far away from Arizona as possible. She immediately headed east for Kansas City, where she launched her show business career as the Arizona Bandit.

Territorial governor Alexander Brodie refused to discuss the reason for her early release, but his secretary, George Smalley, later wrote that Pearl had informed the warden she was pregnant. According to Arizona legend, at the time the only two men who'd been alone with Pearl were the warden and the territorial governor. After a series of telegrams between the capitol and the prison, it was decided to release her immediately. Pearl wasn't pregnant, but she wasn't dumb either and cleverly went on her way, a free woman.

For a brief time, she toured the East reenacting her role on stage as the Arizona Bandit, but the plot was thin and her acting career was brief. Fame was fleeting, and soon Pearl soon drifted back into obscurity.

Nobody knows for certain how Pearl spent her later years, but there is strong evidence she married a cow rancher named Cal Bywater from the Dripping Springs Mountains south of Globe, not far from where she and Joe Boot held up the stagecoach. Pearl became respectable and lived out her life as an honest ranch wife.

10

HUCKSTERS, HUSTLERS, SWINDLERS AND BAMBOOZLERS

*The ways of a man with a maid may be wicked and strange. But simple and
tame; when compared to a man with a mine when buying or selling the same!*
—Bret Harte

The Arizona Territory proved to be an ideal place for swindlers and
con artists to ply their trade. The wild, untamed country that lay
between California and New Mexico bore a king's ransom in gold and silver.
However, it also proved to be fertile ground for silver-tongued swindlers.
Million-dollar corporations were created on nonexistent mines in Arizona's
remote mountains, selling useless stock to eastern speculators. Land fraud
also enriched these grifters, who proved over and over again that P.T. Barnum
was right: "There's a sucker born every minute."

Today's con artists selling lakeshore lots on the edges of mirages are mere
amateurs when compared to those flimflam bamboozlers of yesteryear.

All good con artists have a few things in common: a gift of gab, charisma,
no conscience and absolutely no shame.

The esteemed con man Dr. Richard Flower wasn't really a doctor. He
earned his living for a time selling cure-all bottled medicine. The label on
Doc Flower's medicine bottle claimed to cure, among other things, baldness,
incontinence, impotency and unmentionable female disorders. It would turn
fat into muscle and give a woman a full, rounded bosom. The concoction
contained mostly alcohol, but few complained, especially those little old
ladies who would never think of allowing whiskey to touch their lips.

Doc eventually grew tired of small-time schemes and decided to play for higher stakes. Fortunes were being made in the Arizona mines, and since he didn't have a mine of his own, Doc decided to create one.

He'd never been to Arizona and wouldn't have known a gold nugget from a kernel of cauliflower, but that didn't stop him. He erected a phony movie set–looking mine complete with a head frame and shaft east of Globe near the little town of Geronimo. He bought a few samples of ore from a producing mine and headed back east to locate suckers…er, investors.

Doc returned to New York claiming to have discovered the richest gold mine in the history of the world. He decorated his New York office lavishly and began to sell stock in his "fabulous gold mine." Flamboyant advertising and hard-sell sales pitches brought in suckers by the thousands. Soon, people were begging to buy stock at ten dollars a share. Then it went up to fifteen dollars a share. The rugged town of Geronimo became a household word throughout the eastern states.

He called his company the Spendazuma, a name that revealed Doc's wry sense of humor. Mazuma was slang for money, so he was subtly asking his investors to "spend yer money." Surprisingly, no one caught on. Soon, Doc Flower had suckers waiting in line to lay down their money in a nonexistent mine.

The balloon burst when a reporter named George Smalley from the *Arizona Republican*, today's *Republic*, rode in to have a look at the Spendazuma Mine.

The reporter became suspicious when he looked at the prosperous-looking $10 million mine and took note that workers were as scarce as horseflies in December.

The property was being guarded by an irascible reprobate from Texas named Alkali Tom, who tried unsuccessfully to keep the pesky reporter from snooping around the imaginary gold mine, but Smalley was not to be denied. Barely escaping with his life, he made it to a telegraph station and posted his exposé.

When the story hit the newspapers, Doc's lawyer indignantly threatened to sue for $100,000 and demanded a retraction. When that didn't work, he changed strategies and offered Smalley a $5,000 bribe to rewrite the story and admit his mistake, causing the spunky reporter to chase the lawyer from his office.

Thus ended the Spendazuma Mine swindle, but Doc Flower wasn't easily discouraged. Over the next few years, he was arrested several times for swindling, jumped bail, served some jail time and pulled off several other schemes, including bilking a rich New York widow out of $1 million. Police

chased him all over North and South America before catching up with him in Canada in 1916.

The law never could keep the silver-tongued swindler out of circulation for long, but the Grim Reaper managed to accomplish the feat. He was out on bond again and contemplating another caper when he collapsed and died while sitting in a movie theater in Hoboken, New Jersey.

The Baron of Arizona

Back in the 1880s, a man from Missouri named James Addison Reavis nearly succeeded in pulling off one of the largest land swindles in history.

Reavis was born in Henry County, Missouri, in 1843. When the Civil War broke out, he joined a Confederate unit but soon got homesick and began writing his own military passes, even forging his commanding officer's signature. Soon he was on leave more than he was on duty. Finally, he forged discharge papers and went home for good.

After the war, he found work in a real estate office in St. Louis, where he used his skill in forgery to earn money on some dubious land deals. Honing his skills, Reavis was soon ready for the big time.

Reavis invented a family lineage that began with a Don Nemecio Silva de Peralta de la Córdoba. The fictitious Peralta was given the title of Baron de los Colorados by King Ferdinand VI in 1748, along with a huge grant of land. To explain how he came into possession of the grant, Reavis claimed he acquired a

Master forger James Addison Reavis almost pulled off one of the biggest real estate frauds in American history during the 1880s. *Courtesy of Southwest Studies Archives.*

title from a George Willing, a mine developer, who'd come to Arizona and purchased it from Miguel Peralta, a poverty-stricken descendant of the Baron. Willing had recorded the deed in Prescott in March 1874 and died the next day. Miguel Peralta was also a figment of Reavis's fertile imagination.

The land Reavis claimed was nearly twelve million acres, running through the heart of Arizona. It extended from today's Sun City across to Silver City, New Mexico, including rich mining properties.

The tall, rangy Missourian with the muttonchops beard also had an incredible gift of gab and was a natural born salesman and wheeler-

Doña Sophia Micaela Maso Reavis y Peralta de la Córdoba, third baroness of Arizona. *Courtesy of Southwest Studies Archives.*

dealer. His biggest coup was convincing the owners of the Southern Pacific Railroad and several large mine owners his land grant claim was legitimate.

Reavis needed another connection to the Peralta family, and he found her in the person of a sixteen-year-old orphan girl whom he christened Doña Sophia Micaela Maso Reavis y Peralta de la Córdoba, third baroness of Arizona.

He convinced the youngster she was descended from the Peralta family and then married her. To a master forger it was a simple task to alter church records and make her the last surviving member of the illustrious but fictional Peraltas. He traveled to Mexico City and Guadalajara, spending hours in museums and archives inserting the fictional Peralta family into the archives. Later he went to Spain and did the same in Madrid and Seville.

Reavis experimented with various inks and paper, learning to match the ancient documents. He even bought some anonymous old portraits in a Spanish flea market and designated them as various members of the Peralta lineage.

Reavis didn't plan to evict the occupants from his barony. All he wanted to do was extort enough in fees for rent and quitclaim deeds to support him and his wife in a courtly manner. The railroad gave him $50,000, and the Silver King mine paid $25,000. The large mine owners and railroad nabobs decided it was cheaper to pay the baron his fees rather than fight him and risk losing their valuable properties.

It was the small landowners who took umbrage and caused his undoing. At first they wanted to lynch the smooth-talking baron. The federal government at one point considered paying him millions to settle the claim. Famous lawyers Robert Ingersoll and Roscoe Conkling examined the documents and found them legitimate.

Reavis and Sofia traveled to Europe, where they were welcomed by Spanish aristocracy who were amused to see the baron tweak the nose of the despised *yanquis*. He maintained homes in Arizona; St. Louis; Washington,

Actor Vincent Price starred as the master forger in the 1950 film *The Baron of Arizona*. *Courtesy of Southwest Studies Archives.*

D.C.; Madrid; and Chihuahua City and spent much time traveling with his family. The cattle on his ranches were branded with "PR" and were quickly dubbed the "Swindle Bar Brand."

Everything was going well for the baron, but the wheels of justice were slowly turning to expose the fraud. Investigator Royal Johnson released his report in 1889 disclosing forgeries and historical inaccuracies. One said the calligraphy used in the documents was a recent design. Some parts of the documents were written in quill, while others were in steel pen. The steel pen didn't come into use until the 1800s. Reavis indignantly sued the government for $11 million. He lost the case and was arrested for fraud as he left the courthouse.

In 1895, Reavis was brought to trial, found guilty and sentenced to two years in the penitentiary in Santa Fe and fined $5,000, proving once again that Americans love a creative con man who operates on a grand scale.

The Baron of Arizona was behind bars from July 18, 1896, until April 18, 1898. The baroness Sophia was living in Denver with their two children. He visited New York City; Washington, D.C.; and San Francisco seeking new investors to develop properties, including some irrigation projects in the Arizona's Salt River Valley, but found no takers. He headed for Denver to live with the baroness, but they eventually separated and she divorced him in 1902 for nonsupport. He spent some time living in a poorhouse in California. He died in Denver on November 20, 1914, and was buried in a pauper's grave.

Sophia died on April 5, 1934, going to her grave believing she was descended from a real baroness.

ANTHONY BLUM

Strange things happen in a courtroom, but it would be hard to top the time down in Cochise County when a shameless scoundrel named Anthony Blum bilked a local priest out of $5,000. Blum conned Father Arthur DeBruycher into investing in a "sure thing" gold mine in Gleeson, Arizona. When the mine didn't pan out, the priest filed suit alleging fraud and misrepresentation.

For two years, Blum used a variety of tactics to delay the trial. After he'd exhausted all his excuses, the suit went to trial in Tombstone. Blum was on the stand getting ready to defend himself when suddenly he slumped forward clutching his chest.

His personal physician, who just happened to be in the courtroom, rushed forward, examined him and sadly announced there was no hope. Blum was a goner and would be dead within minutes.

As he lay dying, Blum pleaded for a priest to make his death confession and administer last rites. The only clergy close by on such short notice was the plaintiff, Father DeBruycher.

The court gave the priest permission to proceed hearing Blum's confession and administer absolution. However, these actions placed the priest under the seal of the confession, and he could never reveal what Blum told him.

But wait! A miracle occurred. Apparently, Blum's confession had cleared his conscience and his heart attack. He immediately regained his health. His doctor reexamined him and pronounced him fit to go home.

The trial was put on hold for another year, but since the priest could no longer testify and there were no other witnesses to the scheme, Blum was free to go. The priest was chastised by the Church for bad judgment, and he was out of pocket $5,000.

CYCLONE BILL

Cyclone Bill was a mischievous little shyster and a well-known character to the bartenders around Arizona. He'd studied law as a young man in Texas but didn't practice long. He claimed his first client was a shiftless cowboy charged with stealing cows and assigned to him by the local court. "That cow thief took one look at me and said, 'Yer honor, I plead guilty.'" He went on to say, "So I quit practicing law and went to punching cows."

Somewhere along the way, Cyclone had been shot in the leg, and the wound left him with one leg shorter than the other. Depending on which leg he was standing on, Cyclone could be tall or short. Old-timers around Clifton tell about the time he bellied up to a crowded bar on Chase Street and, standing on his short leg, shouted, "Bartender, drinks for the house."

Drinks were served all around, and while the bartender was distracted, he ducked into the group of imbibers and switched to his tall leg. When the bartender turned around to collect the tab, the short man was nowhere to be found. The red-faced bartender roared, "Where's that little scalawag who ordered drinks for the house?" No one said a word.

During the famous Wham payroll robbery in Graham County in 1889, an eyewitness said one of the bandits limped, so Cyclone, being the "usual

suspect," was arrested. The resulting notoriety gave him his fifteen minutes of fame, and he milked it for all it was worth before producing an alibi.

His real name was William "Abe" Beck, but everyone called him Cyclone Bill. He claimed the nickname came after the railroad reached Yuma in 1877 and there was much money to be made hauling freight by mule team to Tucson. He was hired by a freight company to haul a load of goods from Yuma to the Old Pueblo.

Beck, the freight wagon and the mules never reached their destination. All had mysteriously vanished. A year later, he showed up in Tucson without the rig and was met by the owner, who demanded to know what happened to his goods, wagon and ten-mule team.

Bill claimed that somewhere between Tucson and Yuma a giant cyclone came roaring down and swallowed the mules, wagon and himself, whirling them high in the sky and plopping them back to earth somewhere in Kansas. He vaguely recalled the wild wind blowing him in an eastward direction, so he headed west for about a year until he arrived back to Tucson.

In court, Bill swore he had no idea what happened to the mules, wagon and freight and that he was lucky to get through it alive. The unsympathetic judge presented him with both a jail sentence and a nickname.

THE GREAT DIAMOND HOAX

Of all the schemes during the late nineteenth century, none was more bizarre than one perpetrated by a couple of cousins from Kentucky named Philip Arnold and John Slack.

Arnold and Slack, whose names conjure up thoughts of a vaudeville team, managed to acquire from a friend who worked for a diamond drill company a large number of flawed, industrial-quality or otherwise inexpensive gems of all kinds and began a quest to find a greedy but not-too-sharp investor. They figured California would be the best place to unleash their scheme.

Their "pigeon" was a prosperous San Francisco banker named George Roberts. With dramatic flair, they walked into his office one day in 1871 and emptied a sack of diamonds and other precious gems on his desk. After acquiring his undivided attention, the two hucksters proceeded to stage a great argument about whether they should share their secret and accept financing from outsiders.

Soon the skeptical banker was begging for the opportunity to provide money to develop the huge diamond field located "somewhere" in northeastern Arizona.

Although sworn to secrecy, Roberts shared the information with William C. Ralston, founder of the Bank of California. The two bankers couldn't wait to invest in the venture.

Grubstaked with $50,000, Arnold and Slack left on another expedition and returned three months later looking disheveled, telling harrowing tales of Apache attacks. They were also toting a sack full of precious diamonds.

Ralston sent the gems to an eastern merchant, who pronounced them genuine. Of course they were genuine; Arnold and Slack had purchased them with some of the money the bankers had given them.

Tiffany's of New York became interested in the gems and sent an engineer, Henry Janin, out to examine the diamond field. This presented a slight problem for the two promoters; they had to create a diamond field, so they found a remote mesa in northwestern Colorado and spread a large number of gems around.

Janin was one of the foremost mining engineers in the United States, and his presence should have given credibility to the scheme. However, he was a man with no experience with gemstones, otherwise he would have known that several varieties of precious stones rarely occur in the same place. The famed geologist would become an unwitting partner in the scheme. Tiffany's appraised the diamonds at $150,000, a sum considerably higher than the $20,000 Arnold and Slack had purchased them for in England. It also gave them more money to purchase more uncut gems to lure the investors further into their bold scheme.

Thanks to Janin's report, Tiffany's of New York, the Rothschilds, the Bank of California, Horace Greeley, General George McClellan and General George Dodge all ponied up huge sums of money in the get-rich-quick scheme. A $10 million corporation was formed to exploit the field of precious gems.

The investors insisted they be taken to the site of the gem field, so in June 1872, the two con men took them by rail from St. Louis to Rawlins, Wyoming, and then led them on a circuitous four-day horseback journey into northern Colorado. Finally they came to the location where Arnold and Slack had "salted" the area with precious gems. The investors eagerly gathered in the "treasure."

Arnold and Slack were paid $600,000 to relinquish future claims to the diamond field, and the two proceeded to leave immediately for other parts.

The Great Diamond Hoax was finally exposed when Clarence W. King of the U.S. Geological Survey became suspicious, located the salted mesa and wrote a withering exposé. He noted not only that rubies, emeralds, sapphires and diamonds are not found together in nature but also that none of the stones was recovered from natural surroundings. Most had originated in South Africa. The two con men had purchased cheap cast-off and refuse from jewelers in Amsterdam and London for the sum of $35,000.

King's suspicions were said to have been first confirmed when he found a diamond with a jeweler's facet already polished upon it.

William Ralston, head of the Bank of California; Henry Janin; Charles Tiffany; Baron von Rothschild; and the other investors became the butt of jokes around the world for being hornswoggled by a couple of "hillbillies" from Kentucky.

Philip Arnold returned to his home in Elizabethtown, Kentucky, and became a banker. Authorities eventually managed to find him, and he agreed to pay an undisclosed sum for the promise of immunity. In 1878, he became embroiled in a feud with a rival banker that turned violent and resulted in him being shot and seriously wounded. He died of pneumonia six months later at the age of forty-nine.

John Slack went to St. Louis, where he owned a casket-making company for a time, and then he moved to White Oaks, New Mexico, where he became an undertaker. They never caught up with Slack, and the matter was eventually dropped. Slack died in 1896 at the age of seventy-six.

BAD BOYS OF COCHISE COUNTY

JOHNNY RINGO

Having a catchy "gunfighter" name was almost a sure way to immortality. Writers and dime novelists have turned a few mediocre shooters into legends. Henry McCarty might never have become famous as "Henry the Kid." Nor would James Butler Hickok have done as well with a name like "Wild Jimmy." Arguably, the greatest gunfighter name of them all has to be Johnny Ringo. He might also have been the most overrated gunfighter of them all. He wasn't the fastest or the best by any stretch. Writers described him as a man who had a vast collection of scholarly books and could quote Shakespeare at the drop of a hat. Author John Myers Myers wrote, "He attended college in a day when only men of good background did so." Cochise County deputy sheriff Billy Breakenridge, teller of the tallest Tombstone tales of them all, claimed that he was an educated man with an extensive collection of books, classics, that he read in original Greek and Latin. Truth is, Ringo never even finished grade school, much less high school and college. He is more accurately defined in the title by one of his recent biographers, Jack Burrows, author of *John Ringo, the Gunfighter Who Never Was*.

The legend began to grow shortly after his body was found at Turkey Creek on July 14, 1882. Newspaper accounts of his reckless, erratic behavior inspired writers to create the myth of a gunfighter extraordinaire.

Johnny Ringo had a great name, but his skills as a gunfighter were highly overrated. Courtesy of Southwest Studies Archives.

The name Johnny Ringo certainly helped in this creation. Descriptions such as "fearless" and "King of the Cowboys" along with recollections of "old-timers" were later used by writers to forge his legendary image.

He was born on May 3, 1850, in Washington, Indiana. When he was six, the family moved to Missouri and eventually to California. By 1874, he was in Texas, where he became involved in the Mason County War (Hoodoo War) between German immigrants and native Texans. He was one of the feudists charged and convicted of murder, spending almost two years behind bars before the charges were dismissed. He arrived in Arizona in late 1879.

Ringo was an active participant in the feud between the Earps and the cowboys that culminated with the so-called Gunfight at the O.K. Corral on October 26, 1881. Ringo managed to be absent at that one, but he was suspected of participating in the cowardly shotgun ambush of Tombstone marshal Virgil Earp on December 28, 1881.

His body was found on July 14, 1882, by a wood hauler some twenty-four hours after he'd been shot in the head. In his hand was a pistol containing five cartridges. A cartridge belt was tied around his waist, upside down. A piece of his scalp was missing. His boots were missing, and his feet were wrapped with an undershirt. An inquest was held, and the body was buried. A coroner's jury ruled it suicide. Wyatt Earp later claimed he'd come back to Arizona and killed Ringo. Others say Doc Holliday shot him. Billy Breakenridge blamed Buckskin Frank Leslie. As Billy Claiborne lay dying on Allen Street in Tombstone following a gunfight with Buckskin Frank, his last words were, "Frank Leslie shot John Ringo. I saw him do it." Fred Dodge, undercover agent for Wells Fargo, said Mike O'Rourke, aka Johnny-Behind-the-Deuce, did the deed. Ringo's pal Pony Diehl sought out Johnny and killed him. Was it murder or suicide? Most likely it was the latter, but historians still argue the matter. People love conspiracies, and this one's a favorite.

After his death, Ringo would become the "classic cowboy-gunfighter." He was described as a "strictly honorable man whose word was his bond." Others called him "fearless in the extreme." He was even called the "King of the Cowboys" and a real life Don Quixote. None of this is true. Stealing cows was his stock in trade. His only killing was in the Texas Hoodoo War, when, on September 25, 1875, he and a man named Bill Williams rode up to James Cheyney's place. Cheyney was rumored to have set up a couple of their friends for murder. Cheyney invited the two men to have dinner and was washing his face. The unarmed man's face was covered with a towel, and he didn't see the two draw their pistols. All he heard were the gunshots that took his life.

In December 1879, soon after he arrived in Safford, Arizona, Ringo shot and wounded another unarmed man named Louis Hancock because the latter refused to have a drink with him. These appear to be the classic cowboy-gunfighter's only gunfights.

Joe George, Grant Wheeler and the Flying Pesos Train Robbery

One of Arizona's zaniest train robberies took place five miles west of Willcox on January 30, 1895, when two cowboys named Joe George and Grant Wheeler decided to raise their station in life by robbing the Southern Pacific Railroad.

Since neither had ever heisted a train before, there was going to be a degree of "on-the-job training." So the cowboys turned wannabe train robbers purchased a box of dynamite at a local business in Willcox under the pretense of going prospecting. They cached their blasting powder and hobbled their horses some seven miles west of town and then walked a couple of miles back to meet the train.

West of Willcox was a long grade that slowed the train enough that the two cowpunchers jumped on board with ease. It didn't take much persuasion to entice the engineer to stop the train, especially when he was looking into the muzzle of a Colt .45 revolver.

One of the desperadoes jumped down, uncoupled the passenger cars and signaled the obliging engineer to pull forward with the mail and baggage cars to where the dynamite was stashed.

They broke into the express car and found the Wells Fargo messenger had slipped out the door and hightailed it back to the passenger cars.

Inside the express car were two safes, one a small fragile-looking lockbox and the other a large sturdy-looking Wells Fargo safe. Lying nearby on the floor were several sacks full of Mexican silver dollars, also known as "dobe dollars." At the time they were about the same value as U.S. dollars.

Wheeler and George placed a few sticks of dynamite around the two safes, lit the fuses, jumped out the door and sprawled on the ground, arms covering their heads.

The first blast destroyed the door on the small safe, but the prize, the large Wells Fargo safe, remained intact so they tried again. This time they added a couple extra sticks for good measure. Once again they jumped out of the car and hit the dirt. When the smoke cleared the big safe reappeared, unblemished.

Finally the frustrated train robbers piled the rest of their blasting sticks around the safe and, for ballast, packed eight bags of Mexican silver dollars on top. They struck a match to the fuse and lit out for the nearest cover.

The resounding blast shook the ground from the Dragoons

Train robber Grant Wheeler, along with partner Joe George, blew up a safe, scattering hundreds of pesos in the desert. *Courtesy of Southwest Studies Archives.*

to Dos Cabezas. The entire express car was blown to splinters. Small pieces of lumber and one thousand silver pesos were flung far and wide. It was something of a miracle the two outlaws managed to survive the blast. The flying silver missiles that spewed from the exploding express car impregnated everything they hit, including the telegraph poles alongside the track.

When the smoke cleared, the two amateurs entered the car and found the durable safe door blown off but only a few dollars tucked inside. The real treasure in the express car was the Mexican silver pesos, and they were scattered all over the countryside. The discouraged pair stuffed a few battered coins in their pockets and rode off into the night.

When the train backed into town and sounded the alarm, rather than form a posse to go after the outlaws most of the citizens stampeded out to the scene of the crime to search for silver. It was said that for several years afterward folks were still raking the ground and looking for silver pesos.

It was probably the best manicured piece of desert landscape this side of the town of Paradise Valley, Arizona.

DON'T REACH FOR YOUR SIX-SHOOTER
UNLESS YOU KNOW IT'S THERE

Bill Downing was one of the most disliked fellows in Old Arizona. He was moody, morose, bad-tempered, sullen and surly. And that was when he was sober. He got downright mean and ugly when he was drinking.

Bill was so unlikeable that even members of his gang could barely tolerate him. He was a member of the Burt Alvord gang in Cochise County and was arrested along with Alvord and Billy Stiles for holding up the train near Cochise. Stiles cut a deal with prosecutors to testify against his friends and was released. His proposal to rat on his friends was apparently a scheme because a few days later he walked into the jail in Tombstone, pulled a gun on the jailer and released Alvord and the others but left Downing locked in his cell. Downing spent the next few years cooling his heels in the infamous Yuma Territorial Prison.

After his release in 1907, he returned to Willcox and opened a saloon called the Free and Easy. It soon became a hangout for all the nefarious rascals in that part of Cochise County. That same year, the Arizona Territory had passed a law banning women from "loitering" in saloons, but that didn't stop Bill. He employed an assortment of shady ladies to drink with the customers. He also trained them to be slick-fingered pickpockets, a trade he'd learned in prison.

Their victims were always reluctant to complain because of Bill's reputation as a bad hombre. The law was champing at the bit to arrest him, but the folks around Willcox were so terrorized none would come forward and press charges.

Bill Downing was a member of the Alvord gang
that robbed the Southern Pacific Railroad on
September 9, 1899, near Cochise Station.
Courtesy of Southwest Studies Archives.

That changed when he beat up one of the girls, Cuco Leal, and she complained to the town marshal, who issued a warrant for his arrest.

The best time to serve a warrant to a bibulous reprobate like Bill was early in the morning while he was still groggy from the previous evening's revelry.

Arizona Ranger Billy Speed just happened to be passing through Willcox, and Constable Bud Snow enlisted his help in making the arrest.

On the morning of August 5, 1908, the two lawmen stood in front of the Free and Easy Saloon and called on the old outlaw to step outside. He'd just bellied up to the bar demanding more of the "hair of the dog that bit him" from the night before and ignored the lawmen.

After Ranger Speed called a second time, Bill emptied his glass, turned and headed for the back door.

Like a lot of Old West showdowns, there is more than one version among old-timers as to what happened next. One said if it didn't happen this way it coulda happened that way. Another said if it didn't happen this way it *shoulda* happened that way. This one's my favorite:

Let's call it Cuco's Revenge. Bill had done a good job teaching her the skills of picking some unsuspecting sucker's pocket. That morning, she was standing next to him at the bar, and as he turned to leave, she reached around and removed the pistol from his holster. She was so slick he hadn't realized it had gone missing. He headed out the back door and around the rear of the saloon intending to sneak up on the lawmen and get the drop on them.

Billy Speed anticipated his move and, armed with his .30-40 Winchester, headed in the same direction. The two turned the corner at the same time and faced each other in the classic Old West confrontation.

Bill reached for his pistol. The ranger, seeing the outlaw's hand go toward his hip, raised his rifle and fired.

Much to Bill's surprise and chagrin, his holster was empty. Cuco had had beaten him to the draw…a few moments before the fight.

A coroner's verdict ruled the killing justified, and nobody mourned his passing.

He'd bullied those folks so many times they were just waiting for a chance to turn the tables on him. The incident was the inspiration for an old gunfighter axiom that still holds true: don't reach for your six-shooter unless you know it's there.

RUSSIAN BILL: AN OUTLAW IN THE WORST WAY

Dime novels of the nineteenth century romanticized outlaws of the Old West as noble, free-spirited rapscallions who robbed from the rich and gave to the poor. Common sense tells us the reason they didn't steal from the poor was because there was nothing to steal, and they didn't share their ill-gotten wealth with them either.

Dime novels were read voraciously not only by easterners but foreigners as well. These books even inspired a few wannabes to go west and become outlaws. For some, it was a bad business decision.

For example, one of Arizona's most exotic outlaw wannabes was William Tattenbaum, a young Russian officer in the czar's army. He eagerly devoured these lurid tales from afar and became so enamored of the outlaws of the Old West he deserted the army and came to America to become an outlaw.

He arrived in Tombstone, Arizona, in 1881, all decked out in new cowboy clothes. He'd even carved notches on the handle of his six-shooter to show he'd killed men in battle. When they asked his name, the young man answered in his best, tight-lipped cowboy dime-novel drawl, "They call me Russian Bill."

Russian Bill was quite a novelty in Tombstone. Although he tried to act like an outlaw, he was much too refined to be taken seriously. The tall, handsome, curly-headed blond spoke several languages fluently and was quite intelligent. Quoting Greek and Latin, he charmed the shady ladies of Tombstone and Galeyville. Curly Bill and the other outlaws were amused and even let the Russian join their gang.

Still, Russian Bill felt like a phony. He was hanging out with some of the most disreputable outlaws in the West, yet he'd never committed a crime.

So to certify his claim, he rustled a few cows. It was the work of an amateur, and Bill was quickly captured and thrown into the pokey at Shakespeare, New Mexico. There he was reunited with a cohort from Tombstone named Sandy King.

The locals apparently hadn't read the glorified accounts in dime novels of outlaws who robbed from the rich and gave to the poor. A vigilance committee convened and sentenced the two to hang, calling one an outlaw and the other a "damned nuisance."

Bill and Sandy were placed on their horses and hanged from the beams of the dining hall of the Grant Hotel, which also served as the station for the transcontinental stagecoach line. The next morning when the stage arrived, the passengers disembarked and went in for breakfast. They were greeted by two dead outlaws dangling from the rafters. It's no wonder easterners had such an adverse perception of the Wild and Wooly West.

An enduring legend along the Mexican border says that when Bill's mother, the Countess Telfrin in Moscow, inquired as to the circumstances surrounding her son's death, she was told he died of shortage of breath—while at a high altitude.

ZWING HUNT

According to Cochise County deputy sheriff Billy Breakenridge, Zwing Hunt was one of the worst outlaws in that hell-for-leather county. He came from Texas and was from a good family, but somewhere along the way he went bad. He arrived in Arizona with another hellion named Billy Grounds. For a spell, Hunt worked as a cowboy for the Chiricahua Cattle Company but soon turned to outlawry. He and Billy began by rustling cattle but got into more serious crime when they ambushed a party of Mexicans who were smuggling silver bullion and silver dollars out of Mexico. They killed everyone in the party and left them in what is known today as Skeleton Canyon. They buried the spoils somewhere in the canyon, and today it remains one of Arizona's illustrious lost treasure stories.

Apparently, Zwing and Billy had some other escapades into Mexico. An alleged deathbed tale by Zwing claimed they rode out of Mexico following a three-month raid with two four-horse wagons loaded with plunder.

They hung out with a hell-raising crowd that included Johnny Ringo, Curly Bill Brocius, Tom and Frank McLaury and the Clanton brothers.

In the fall of 1881, some thirty head of cattle were stolen in the Sulphur Springs Valley, and the tracks led to a corral where they had been sold to a local butcher in the town of Charleston on the San Pedro River. The description of the rustlers matched that of Zwing Hunt and Billy Grounds. The pair escaped arrest by hightailing it into Mexico.

The following spring, two masked men with rifles entered the office of the Tombstone Mining Company and, without saying a word, shot and killed chief engineer M.R. Peel and then disappeared into the darkness. It was believed that they only planned to rob the company but one fired his weapon accidentally.

A few days later, word reached the sheriff's office in Tombstone that the two suspects, Zwing Hunt and Billy Grounds, were holed up at the Chandler Ranch, some nine miles outside of town.

Sheriff John Behan was out with another posse at the time, so Deputy Billy Breakenridge had the responsibility of going after the bandits. He gathered a small posse of five men to join him, and they rode to the ranch, arriving just before daylight on the morning of March 29, 1882.

Breakenridge placed two possemen, Jack Young and John Gillespie, watching the back door of the ranch house while he and Hugh Allen guarded the front. Gillespie, aspiring to be a hero, walked up and pounded on the door, shouting, "It's me, the sheriff." The door opened, and Gillespie was shot dead. Another bullet shot Young through the thigh.

Then the front door opened, and a shot rang out, hitting Allen in the neck and knocking him to the ground. Breakenridge grabbed Allen by the shirt, dragged him to safety and then jumped behind a tree just as another shot hit nearby. Just then, the shooter, Billy Grounds, stepped into the doorway to fire another round. Breakenridge raised his shotgun and fired, hitting Billy in the face. The outlaw fell, mortally wounded.

In the meantime, Allen had regained consciousness and grabbed a rifle just as Zwing Hunt came around the side of the house. Both Breakenridge and Allen opened fire, hitting the outlaw in the chest. The battle had lasted only two minutes, and during that time, two men were killed and three wounded.

The dead and wounded were loaded up on a milk wagon and hauled into Tombstone.

Zwing Hunt, while recovering from his wounds, managed to escape with the help of his brother, Hugh, who came over from Texas. Hugh would later claim that Zwing was killed by Apaches, but others swore he escaped back to Texas, where, on his deathbed, he drew a map leading to the buried outlaw treasure. Folks are still looking for it, but so far it's still out there somewhere.

BUCKSKIN FRANK LESLIE

Early Arizona was graced with a number of colorful characters with picturesquely whimsical names like Long-Necked Charlie Leisure, Shoot-Em-Up Dick, Long Hair Sprague, Red Jacket Almer, Lafayette Grime, Rattlesnake Bill, Johnny-Behind-the-Duece, Three-Finger Jack, Bravo Juan, Peg Leg Wilson and Jawbone Clark.

Along with those are a few lesser known, such as Coal Oil Georgie, Senator Few Clothes and Harelip Charley Smith.

Charming specimens of Eve's flesh included Nellie the Pig, the Waddling Duck, the Dancing Heifer, the Galloping Cow, the Roaring Gimlet, Little Lost Chicken, Grasshopper, Madame Featherlegs, Peg Leg Annie, Dutch Jake, Nervous Jessie, Snake Hips Lulu and Lizzette-the-Flying Nymph.

Joining these pariahs of society was Nashville Frank Leslie, better known as Buckskin Frank Leslie. Buckskin was only five feet, seven inches tall and weighed 135 pounds. He was a handsome, dashing rogue and was also quite a ladies' man. He had a hot temper and was prone to being violent when he was drinking. That would eventually be his undoing.

Frank's early years were spent as an Indian scout for the army in Texas, Oklahoma, the Dakotas and later in Arizona. He arrived in Tombstone around 1880, where he easily slid into the raucous social life of Arizona's largest boomtown. He was also good with a gun and was said to have killed fourteen men. He's best

Buckskin Franklin Leslie had been an army scout, gambler, gunman and lawman. During a drunken, jealous rage, he shot and killed his lover, Mollie Williams. *Courtesy of Southwest Studies Archives.*

known for his gunfight on the evening of November 14, 1882, with the self-anointed "Billy the Kid" Claiborne, a member of a loose-knit gang of cattle rustlers known as the Cowboys.

The real Billy the Kid was gunned down in the summer of 1881 by Lincoln County sheriff Pat Garrett, and Claiborne was now demanding folks apply that name to him. Locals, however, recalled that Claiborne had run away from the gunfight near the O.K. Corral leaving three of his pals to die. It was not the stuff of a real gunfighter, so Billy sought to repair his tarnished image by going around Tombstone with a chip on his shoulder.

That evening, Billy was drunk in the Oriental Saloon and made the mistake of insisting Buckskin Frank Leslie refer to him as Billy the Kid. Naturally, Leslie refused, something that enraged Claiborne. He got his hands on a Winchester and began telling everyone he was going to shoot Leslie on sight. When the buckskin man learned of the threat, he left the Oriental and met Billy in the street, where a gunfight ensued. Billy fired and missed. Frank fired and didn't.

Among Leslie's many amorous conquests was a married but separated lady named Mae Killeen. Her estranged husband, however, wasn't willing to share his wife and threatened to shoot any man who made a pass at her. Leslie began escorting the dark-haired beauty around town, and when Killeen discovered the two sitting together on the veranda of the Cosmopolitan Hotel on the evening of June 22, 1880, he flew into a jealous rage. The two exchanged gunfire, and when the smoke cleared, Killeen would soon be pushing up daisies on boot hill. A week later, Leslie and the buxom widow were married. They split the blanket seven years later, allegedly after she grew tired of him making her stand against the wall while he traced her silhouette with bullets from his six-shooter.

Next, Leslie took up with a singer-prostitute named Mollie Williams (or Sawyer, or Bradshaw, or just plain Blonde Mollie). He may have killed her "benefactor," a man named Bradshaw, and soon, the two were living together in what is best described as a stormy relationship. What Leslie and Mollie had most in common was their love of whiskey, and it led to many an argument. On July 10, 1889, at a ranch in the Swisshelm Mountains east of Tombstone, he killed her in a drunken fit of jealousy after accusing her of having an affair with a ranch hand known as "Six-Shooter" Jim Neil. Neil was a witness to the shooting, and afterward Leslie turned and shot him too. Leslie thought he'd killed Neil, but the youngster lived to testify against Frank for the murder of Mollie. The law finally

The body of Mollie Williams was laid to rest in a lonely spot in the Swisshelm Mountains of Cochise County. *Author's collection.*

caught up with Frank, and he was sentenced to twenty-five years in the Yuma Territorial Prison.

Frank was pardoned and released in November 1896, thanks in part to a wealthy widow named Belle Stowell. She'd fallen in love with the famous gunfighter while he was behind bars and began corresponding with him. They became husband and wife less than a month after his release. Somewhere along the way, they parted company, and he married Elnora Cast. History doesn't record whether or not he ever bothered with divorcing any of her predecessors.

He seems to have disappeared around 1922, and his death is still disputed. One source says he committed suicide in 1925, while another says he struck it rich in the Klondike and died that way in the San Joaquin Valley.

The best information indicates his last years, drunk and penniless, were spent working as a swamper in a San Francisco pool, dying in 1930 at the age of about eighty.

The circumstances concerning Buckskin Frank's death remain shrouded in mystery.

CURLY BILL BROCIUS: OUTLAW KING OF GALEYVILLE

His true name remains a mystery. Some accounts say it was William Brocius Graham, while others claim it was William Brocius or William Graham, but in outlaw lore, he was known as Curly Bill Brocius. Little of his past can be substantiated. Curly Bill left no letters or provided any information on his life before coming to Arizona, where he drifted after working as a cowhand in Texas and then in New Mexico. Supposedly he acquired his colorful nickname from a Mexican cantina girl who was enthralled with his dark, curly hair, but even that has been disputed.

Cochise County deputy sheriff Billy Breakenridge described him as being "fully six feet tall, with black curly hair, freckled face and well built." No documented photos have been found, and there are no details regarding his mother and father. In short, he was a mysterious man from nowhere.

Curly Bill figured prominently in the outlawry along the Mexican border in the early 1880s. He was personally responsible for rustling thousands of Mexican longhorns and earned the dubious distinction of having his name mentioned in a number of hotly worded diplomatic notes exchanged between the United States and Mexico.

Like many notorious Wild West figures, Curly Bill had an inflated reputation as a gunslinger. However, the outlaws of Cochise County were a tough breed, and the fact that Curly Bill was a leader says something about respect. He hung out in Galeyville, a small community on the east side of the Chiricahua Mountains, where he was known as the "Outlaw King of Galeyville."

His notorious Arizona reputation began sometime around midnight on October 28, 1880. Curly Bill was on a wild binge in Tombstone. He stepped out in the street, pulled his six-gun and started shooting holes in the sky. Town marshal Fred White attempted to disarm the drunken cowboy, but when Curly Bill surrendered his pistol, it went off and Marshal White fell, mortally wounded. Did Curly Bill murder White, or was it an accident? Whichever it was, henceforth it became known as the "Curly Bill Spin."

Wyatt Earp was standing nearby when it happened. He whacked Bill upside the head with the barrel of his pistol, knocking him senseless, and then hauled him off to jail. Fearing a mob would lynch him, Wyatt took him to Tucson, where Bill spent some time in the Tucson jail before being acquitted by a jury packed with his cowboy pals. He was released from jail on December 27. Before White died, he exonerated Curly Bill by saying the shooting was an accident, and that's all that saved the outlaw king from

a hangman's noose. During his trial, Judge Joe Neugass called the killing "homicide by misadventure."

Fresh out of jail, Bill went on a rampage, terrorizing the towns and tormenting the citizens of Charleston, Contention City and Watervale along the San Pedro River. Bill was known around Arizona as an impulsive devil-may-care cowboy known to go on a tear at the drop of a hat. Newspapers referred to him as the terror of Cochise County. One wrote, "His playful exhibition of his skill with a pistol never failed to delight those communities which the peripatetic William favored with his presence."

On January 8, 1881, Bill and another cowboy invited themselves to a Mexican fandango. One blocked the front door, while the other took the back. They pulled their pistols, yelled for the music to stop and ordered everyone to strip naked. Then he ordered the band to strike up the music and the dancers to dance for their amusement.

The following day, the two cowboys went into a church at Contention and interrupted the sermon by telling the reverend to quit preaching or he'd shoot his eye out. Then, warning him to stand perfectly still, the boys took turns shooting close to his head. They then aimed their pistols at his feet and made him dance a jig.

The boys then headed for Tombstone, where they got good and drunk and then rode down Allen Street "shooting holes in the sky."

Nine days later, they rode into Contention City, robbed a till of fifty dollars and fired off a round at a citizen. After spending a day terrorizing the locals they rode on to nearby Watervale. From there Bill dared authorities to "come and get me."

Bill's shenanigans drew national publicity and made him the most famous outlaw in wild and wooly Arizona.

Bill didn't limit his antics to Arizona, though. One night in Silver City, he burned down a saloon after he shot out a lamp, causing it to explode. Another time he shot a hole in a freighter's hat for his own amusement. He also shot a hole in the hat belonging to a reporter who wrote a story the gunman didn't appreciate.

At Fort Bowie, after telling a soldier to hold up a coin, Bill commenced to fire and knock it from between his fingers. Bill decided to try again, but this time he shot off the soldier's thumb. Bill's response to that was, "Looks like I've just gotten you a discharge from the army."

One time in Galeyville, a saloonkeeper was getting ready to take a drink from a tin cup when Curly Bill shot it out of his hand. Unfortunately, the bullet went through the wooden wall and killed Bill's horse.

Another time in Galeyville, he went into a restaurant, ordered a meal and then placed a six-shooter on each side of his plate and ordered everyone to wait until he was through eating before they could leave. When he finished, Curly Bill laid his head down on his arms and fell asleep. Although he was snoring loudly, everyone was still afraid to move. Sometime later he awoke, paid for everyone's meal and left.

The so-called outlaw chief even assisted Deputy Breakenridge with collecting taxes, taking him into the lair of the cattle thieves, cajoling his pals to be "good citizens" and divvy up. Considering Breakenridge's reputation for coloring up a story, this might be another one of his tall tales.

Galeyville was a rough town that had more than its share of outlaws and hard cases. Rough men and rough humor often led to bloodshed, even among their own. On May 19, 1881, Bill got into an altercation there with a cowboy from New Mexico named Jim Wallace. When Curly Bill stepped out of a saloon, Wallace bushwhacked him. The bullet struck Curly Bill in the cheek, went through and came out the other side of his mouth, taking some teeth. It looked for a while like the outlaw king was going to die, and his friends made plans to string up Wallace. But Curly Bill had a strong constitution, and he survived, although he did have to spend the next few weeks with an awkward bandage wrapped around his head.

Curly Bill wasn't present at the so-called Gunfight at the O.K. Corral on October 26, 1881. No one seems to know for sure where both he and Johnny Ringo were that fateful day, but had they been present, the classic gunfight might have ended differently; if for no other reason, they would have provided more firepower.

During the months following the street fight in Tombstone, the Cowboys resorted to ambushing their enemies. On the evening of December 28, 1881, Virgil Earp was shot from ambush while patrolling the streets of Tombstone. Then, a few weeks later, on March 18, 1882, Morgan Earp was gunned down by an assassin.

The next day, the coroner's jury included Curly Bill among seven suspected assassins. But once again, friends of the suspects provided alibis for them, and they were all released, proving once more that a cowboy couldn't be convicted in Cochise County. Wyatt knew the only way justice would be served for the shooting of his brothers would be for him to take the law into his own hands. He would be his brothers' avenger, becoming judge, jury and executioner. Wyatt led a small posse of friends on a vendetta against the perpetrators.

On March 21 at Iron Springs, in the Whetstone Mountains west of Tombstone, Wyatt and Curly Bill met again. There was a furious exchange of gunfire, and when the smoke cleared, Curly Bill lay dead on the ground.

Bill's friends denied their leader died at the hands of Wyatt Earp. Some said he went to Mexico, married a pretty *señorita* and produced a bunch of kids; others said he went to Colorado and got a new start; still others said he went back to Texas.

Did Wyatt kill Curly Bill? Truth is, nobody was ever able to prove he didn't. The *Tombstone Epitaph*, the newspaper supporting the Earps, ran a story agreeing with Wyatt's version, and the Cowboy organ, the *Nugget*, sided with the Cowboys. They claimed he'd been miles away and offered a $1,000 reward to anyone who could produce Curly Bill's dead carcass. In response, the *Epitaph* offered a $2,000 reward to anyone who could produce a *live* Curly Bill. Surely Curly Bill himself couldn't have resisted an offer like that. One thing is certain: no one ever saw or heard from him again.

BIBLIOGRAPHY

Buckey O'Neill and the Train Robbers

Barnes, Will C. *Apaches and Longhorns*. Los Angeles: Ward Ritchie Press, 1941.

Herner, Charles. *The Arizona Rough Riders*. Tucson: University of Arizona Press, 1970.

Hietter, Paul. "No Better than Murderers: The 1889 Canyon Diablo Train Robbery and the Death Penalty in Arizona Territory." *Journal of Arizona History* (Autumn 2006).

Tinsley, Jim Bob. *The Hash Knife Brand*. Tampa: University of Florida Press, 1993.

Trimble, Marshall. *Arizona Adventure*. Phoenix, AZ: Golden West, 1982.

Walker, Dale. *Death Was the Black Horse*. Austin, TX: Madrona Press, 1975.

Jim Roberts: The Pleasant Valley War's Top Gun

Dedera, Don. *A Little War of Our Own*. Flagstaff, AZ: Northland Press, 1988.

Forrest, Earle R. *Arizona's Dark and Bloody Ground*. Caldwell, ID: Caxton Printers, 1959.

Pyle, Jinx. *Pleasant Valley War*. Payson, AZ: Git A Rope Publishing, 2009.
Trimble, Marshall. *Arizona Adventure*. Phoenix, AZ: Golden West, 1982.
———. *In Old Arizona*. Phoenix, AZ: Golden West, 1985.
Wampler, Vance. *Arizona: Years of Courage*. Phoenix, AZ: Quail Run, 1984.
Young, Herbert. *They Came to Jerome*. Jerome, AZ: Jerome Historical
 Society, 1972.

Interviews

Allen, Fern. Historian for Roberts-Kirkland family.
Brunson, George Andy. Young, AZ. 1996
Chapman, Frank. Young, AZ, 1996.
Hanchett, Lee. 1994.
Haught, Tobe. Young, AZ, 1996.
Roberts, Bill. 1970–72. (Bill was a son of Jim Roberts.)

THE VANISHING TRAIN ROBBERS

Myrick, David. *Railroads of Arizona*. Vol. 1. Berkeley, CA: Howell North
 Books, 1975.
Trimble, Marshall. *Arizoniana: Stories from Old Arizona*. Phoenix, AZ: Golden
 West Publishers, 1988.

COMMODORE PERRY OWENS: BRINGING LAW AND ORDER TO APACHE COUNTY

Ackerman, Rita. *OK Corral Postscript: The Death of Ike Clanton*. Honolulu, HI:
 Talei Publishers, 2006.
Ball, Larry. "Commodore Perry Owens: The Man Behind the Legend."
 Journal of Arizona History (Spring 1992).
Barnes, Will C. *Apaches and Longhorns*. Los Angeles: Ward Ritchie Press, 1941.
Dedera, Don. *A Little War of Our Own*. Flagstaff, AZ: Northland Press, 1988.
Forrest, Earle R. *Arizona's Dark and Bloody Ground*. Caldwell, ID: Caxton
 Press, 1936.

Hanchett, Leland J. *The Crooked Trail to Holbrook*. Phoenix, AZ: Arrowhead Press, 1993.

Jeffers, Jo Johnson (Baeza). "Commodore Perry Owens." *Arizona Highways* (October 1960).

Peace-Pyle, Jayne. *Women of the Pleasant Valley War*. Payson, AZ: Git A Rope Publishing, 2010.

Pyle, Jinx. *The Pleasant Valley War*. Payson, AZ: Git A Rope Publishing, 2009.

Tinsley, Jim Bob. *The Hash Knife Brand*. Tampa: University of Florida Press, 1993.

Trimble, Marshall. *Arizona Adventure*. Phoenix, AZ: Golden West, 1982.

Special thanks to Rim Country historians Jo Baeza, Jayne Peace Pyle and Jinx Pyle of Payson for sharing their research and information on the Pleasant Valley War.

Thanks also to Frank Chapman, who lives on the old Tewksbury ranch, and former Gila County deputy sheriff George "Andy" Brunson of Globe for spending many hours showing me the "lay of the land" in Pleasant Valley.

Climax Jim: Arizona's Lady Godiva

Barney, James. "Climax Jim, My Favorite Outlaw." *Arizona Highways Magazine* (April 1995).

Miller, Joseph. *The Arizona Story*. New York: Hastings House Publishers, 1952.

Patton, James. *History of Clifton*. Clifton, AZ: Greenlee County Chamber of Commerce, 1977.

For Further Reading

Tanner, Karen Holliday, and John D. Tanner. *Climax Jim: The Tumultuous Tale of Arizona's Rustling Cowboy*. Tucson, AZ: Arizona Lithographers, 2005.

Texas John Slaughter

During the 1950s, in the early days of color television, Walt Disney Productions made a film about John Slaughter, starring Tom Tryon as Texas John Slaughter.

Arizona Highways (October 1986, February 2000 and January 2006).

Erwin, Allen A. *The Southwest of John Horton Slaughter*. Glendale, CA: Arthur H. Clark Co., 1965.

Traywick, Ben. *That Wicked Little Gringo: The Story of Tombstone's John Slaughter*. Tombstone, AZ: Red Maries Books, 2001.

Wagoner, J.J. *Early Arizona*. Tucson: University of Arizona Press, 1975.

George Ruffner: Sheriff of Old Yavapai

Ruffner, Lester "Budge." Interview, Prescott, AZ, October 18, 1994.

Trimble, Marshall. *Arizona: A Cavalcade of History*. Tucson, AZ: Treasure Chest Publications, 1989.

Way, Thomas E. *The Parker Story*. Prescott, AZ: Prescott Graphics, 1981.

Burt Mossman: Captain of the Arizona Rangers

Miller, Joseph, ed. *The Arizona Rangers*. New York: Hastings House, 1972.

O'Neal, Bill. *The Arizona Rangers*. Austin, TX: Eakin Press, 1987.

Raine, William MacLeod, and Will C. Barnes. *Cattle, Cowboys and Rangers*. New York: Gosset and Dunlap, 1930.

Trimble, Marshall. *Arizona Adventure*. Phoenix, AZ: Golden West. 1982.

Pearl Hart: The Girl Bandit

Lauer, Charles. *Tales of Arizona Territory*. Phoenix, AZ: Golden West Publishers, 1990

Parker, Lowell. *Arizona Towns and Tales*. Phoenix, AZ: Phoenix Newspapers, Inc., 1975.

Smalley, George. *My Adventures in Arizona*. Tucson: Arizona Pioneers Historical Society, 1966.

BIBLIOGRAPHY

HUCKSTERS, HUSTLERS, SWINDLERS AND BAMBOOZLERS

Parker, Lowell. *Arizona Towns and Tales*. Phoenix, AZ: Phoenix Newspapers, Inc., 1975.

Smalley, George. *My Adventures in Arizona*. Tucson: Arizona Pioneers Historical Society, 1966.

Trimble, Marshall. *Arizoniana*. Phoenix, AZ: Golden West Publishers, 1988.

BAD BOYS OF COCHISE COUNTY

Barra, Allen. *Inventing Wyatt Earp: His Life and Many Legends*. New York: Carroll and Graf, 1998.

Bell, Bob Boze. *The Illustrated Life and Times of Wyatt Earp*. Phoenix, AZ: Tri Star Boze, 1994.

Breakenridge, Billy. *Helldorado*. Boston: Houghton Mifflin, 1928.

Breihan, Carl. *Great Lawmen of the Old West*. New York: Bonanza Books, 1963.

Burrows, Jack. *John Ringo, the Gunfighter Who Never Was*. Tucson: University of Arizona Press, 1987.

Gatto, Steve. *Curly Bill*. Lansing, MI: Protar House, 2003.

———. *Johnny Ringo*. Lansing, MI: Protar House, 2002.

Horan, James. *The Gunfighters*. New York: Gramercy Books, 1976.

Metz, Leon. *The Encyclopedia of Lawmen, Outlaws and Gunfighters*. New York: Facts on File, Inc., 2003.

O'Neal, Bill. *Encyclopedia of Western Gunfighters*. Norman: University of Oklahoma Press, 1979.

Roberts, Gary. *Doc Holliday: The Life and the Legend*. Hoboken, NJ: John Wiley and Sons, 2006.

Tefertiller, Casey. *Wyatt Earp: The Life Behind the Legend*. New York: John Wiley and Sons, 1997.

INDEX

A

Alkali Tom 105
Alvord, Burt 93, 118
Apodaca, Miguel 29
Arnold, Philip 111, 113

B

Baeza, Jo 39, 57, 133
Banta, A.F. 55
Barnes, Will C. 24, 51
Barrett, Elizabeth 61
Beck, William "Abe" 111
Behan, John 122
Billy the Kid. *See* Bonney, William
Birchett, Molly 76
Black, Jim 12
Blaine, George 24
Blevins, Charley 24, 29, 49, 50, 57
Blevins, Eva 53
Blevins, Hamp 24, 25, 26, 29, 49, 50, 51, 57
Blevins, John 26, 29, 52, 53, 54, 55, 56, 57
Blevins, Mart 24, 26, 50
Blevins, Mary 53, 56, 57

Blevins, Sam Houston 53, 55
Blum, Anthony 109
Bonney, William 70
Boot, Joe 100, 103
Boyer, Joe 24, 27, 29
Bradford, R.T. 37
Breakenridge, Billy 115, 121, 122, 126
Brighton, Jonas V. "Rawhide Jake" 43, 46, 47, 48
Brocius, Curly Bill 121, 126
Brodie, Alexander 103
Broglum, Solon 16
Brown, Sam 52
Buggeln, Martin 78
Bywater, Cal 103

C

Cameron, Ralph 81
Canyon Diablo 12
Carrington, Bob 24, 25
Cast, Elnora 125
Chacon, Augustine 92, 93, 98
Chew, Sid 32
Cheyney, James 116
Clanton, Fin 44, 48

Index

Clanton, Ike 44, 45, 46, 47, 48, 70
Clanton, Newman Haynes "Old Man" 44
Clark, Ben 65
Climax Jim 62, 63, 64, 65, 66
Colossal Cave 38
Conkling, Roscoe 108
Connor, Margaret 17
Cook, Dean 21
Cook, George 91
Cooper, Andy 24, 26, 27, 46, 49, 50, 51, 55, 56, 58
Crocker, Dud 32
Cyclone Bill 110, 111

D

DeBruycher, Father Arthur 109
Diehl, Pony 115
Doan, Fletcher 101
Dodge, General George 112
Doña Sophia Micaela Maso Reavis y Peralta de la Córdoba 107
Downing, Bill 94, 118
Dunlap, "Three-Finger Jack" 94

E

Earp, Morgan 128
Earp, Virgil 128
Earp, Wyatt 11, 44, 115, 126, 129
Ellinger, Isaac 46
Ellinger, William 46
Ellingwood, Joe 28
Ellison, Colonel Jesse 30
Evans, Billy 45, 47

F

Flossie 83
Flower, Dr. Richard 104
Fly, C.S. 70
Fornoff, Fred 12
Forrester, Will 17, 20

G

Gallagher, Barney 69
Garfias, Henry 11, 30
Gatto, Steve 48
George, Joe 116
Geronimo 71, 105
Ghuey, Louey 41
Gibson, Hoot 19
Gladden, Amanda 53, 56
Glaspie, Bob 24, 25
Graham, Anne Melton 30
Graham, John 23, 24, 26, 29
Graham, Tom 27, 28, 29, 30
Greeley, Horace 112
Greene, Bill 96
Grigsby, Dick 41
Grounds, Billy 121, 122
Grover, Bert 91, 94
Gunfight at the O.K. Corral 44, 115, 128
Guthrie, Jim 37

H

Hale, Jim 45
Halford, John 11
Harper, Bill 36
Harris, Eliza Adeline 69
Hart, Frederick 99
Hart, Pearl 99
Harvey, D.G. 52
Harvick, Dan 11
Hash Knife 16, 23, 24, 42, 59, 63, 64, 79, 88, 89
Hat Ranch 76, 81
Hawkins, Joe 32
Hawkins, John 82
Holbrook, H.R. 41
Holcomb, D.B. 56
Holliday, Doc 11, 45
Holton, Carl 12
Hooker, Henry Clay 71
Howell, Amazon 70
Howell, Cora Viola 70
Hubbell, John Lorenzo 43

Hunt, George W.P. 26
Huntington, Sandy 73, 74
Hunt, Zwing 121, 122

I

Ingersoll, Robert 108
Iron Springs 129

J

Jacobs, Bill 24, 27, 28, 51
Janin, Henry 112, 113
John Gillespie 122
Jones, Buck 19

K

Kane Springs 100
King, Clarence W. 113
King, Sandy 121
Kirkham, Jane 99
Kirkland, Permelia 31
Kirkland, William 31
Kosterlitzky, Emilio 68, 91

L

Land and Cattle Company 41, 42, 89
Leal, Cuco 119
Lee's Ferry 13
Leslie, Buckskin Frank 115, 123
Lowery, Jim 32

M

Marston, Marion 17
Marvin, Pug 77
Maxwell, Bill 90
McCarty, Henry 114
McClellan, George 112
McKinney, Joe 46
McLaury, Frank 121
McNeil, Red 59, 60
Meadows, John 27, 29
Meyers, Dick 38
Middleton, Harry 28

Miller, Albert 46, 47
Miller, Hog-Eye 76, 81
Milton, Jeff 46, 94
Mix, Tom 19, 20
Mossman, Burt 64, 85, 87, 89, 92, 94, 95, 98
Mulvenon, Billy 29
Musgrave, George 90

N

Neill, Witt 90
Nelson, Earl 17, 18, 20
Nephew, Rufus. *See* Climax Jim
Neugass, Joe 127
Norris, Lee 79, 82

O

O'Neill, Buckey 15, 16
Orient Saloon 91
Owens, Commodore Perry 26, 29, 39, 43, 50, 53, 58, 59, 61

P

Page, Leonard 92
Paine, John 24, 25
Palace Saloon 74, 75
Panguitch, Utah 15
Parker, Fleming 75, 76, 77, 78, 81, 82, 84
Parks, Jim 90, 96
Parks, John 90
Peel, M.R. 122
Peralta, Miguel 107
Plummer, Pratt 46
Pyle, Jayne Peace 56, 57, 133

R

Ralston, William 113
Reavis, James Addison 106
Renfro, Lee 45, 46, 47
Rhodes, John 26, 27, 28, 30
Riley, One-Eye 78
Ringo, Johnny 11, 114, 115, 121, 128

Roberts, George 111
Roberts, Jim 17, 19, 20, 21, 22, 24, 25, 26, 27, 28, 29, 31, 33, 34, 35, 80
Roberts, Joe 91
Roberts, Mote 26, 53, 55, 56
Robinson, Dr. T.P. 56
Roosevelt, Teddy 15, 100
Rose, Al 29
Rothschild, Baron von 113
Ruffner, Budge 73, 84
Ruffner, George 20, 73, 74, 75, 76, 78, 79, 83, 84
Ruffner, Morris A. "Andy" 74
Russian Bill 120
Rustler's Roost Canyon 77

S

Salcito, Pablo 92
San Bernardino Land Grant 70
Sarata, Cornella 78, 80
Saunders, David 18
Schultes, Lydia 23
Skeleton Canyon 71, 121
Slack, John 111, 113
Slaughter, John 48, 67, 68, 69, 70, 71, 72, 94, 133
Sloan, Richard E. 31
Smalley, George 63, 103, 105
Smart, J.M. "Doc" 36
Smith, Bill 90
Smith, Charlie 36, 37
Smith, Harelip Charley 123
Smith, J. Ernest 38
Smith, J.J. 11
Smith, Kid 38
Solomonville 90, 91, 93, 96
Southard, Bob 17
Speed, Billy 119
Spendazuma Mine 105
Sprague, Longhair 45, 47
Stanley, Ebin 45, 48
Star-Bar-Circle Cattle Company 65
St. Clair, Ed 12
Sterin, Bill 11

Stiles, Billy 93, 94, 95, 96, 118
Stinson, Jim 22, 23
St. Johns Herald 43, 44, 46, 47, 50, 56
Stowell, Belle 125
Summers, Jim 78
Sureshot 79, 80, 81, 84
Swingle, G.W. "Kid" 45

T

Tafolla, Carlos 90, 92
Tattenbaum, William. *See* Russian Bill
Tewksbury, Ed 23, 24, 26, 28, 30, 31
Tewksbury, Frank 23
Tewksbury, James Dunning 22
Thompson, Abe 77, 82
Thompson, John "Rim Rock" 63
Thornton, George 75
Tiffany, Charles 113
Tovrea, Ed 89
Traywick, Ben 45
Tucker, Tom 24, 25

V

Villa, Pancho 71

W

Wallace, Jim 128
Wallace, Lew 70
Wattron, Frank 52, 53, 56, 58
Wheeler, Grant 116
White, Fred 126
Williams, Mollie 124
Willing, George 107
Wilson, George 24
Wilson, James "Peg Leg" 47
Wilson, Windy 77

Y

Yoas, "Bravo Juan" 94
Young, Jack 122
Young, Silas 30

ABOUT THE AUTHOR

MARSHALL TRIMBLE: ARIZONA'S OFFICIAL
STATE HISTORIAN

Marshall Trimble has been called the "Will Rogers of Arizona." He's a "cowboy philosopher," educator, lecturer, folk singer and stage performer. He appears frequently on radio and television as a goodwill ambassador for the state. He taught Arizona history at Scottsdale Community College for forty years.

His first book, *Arizona*, was published in 1977 by Doubleday in New York. Since then, he's written more than twenty books on Arizona and the West.

He answers questions about the Old West in *True West Magazine*'s popular column, "Ask the Marshall." In 2006, he received a regional Emmy for hosting the television show *Arizona Backroads*.

A former marine, in 2004, he was inducted into the Arizona Veterans Hall of Fame and is a founding member of the Arizona Peace Officer Memorial Board for lawmen killed in the line of duty.

In 2007, the Arizona Office of Tourism honored him with a Lifetime Achievement Award for his many years of service to his native state. He served on the Arizona Centennial Commission from 2008 to 2012. In 2010, he received the Wild West History Association's Lifetime Achievement Award.

ABOUT THE AUTHOR

He was inducted into the Arizona Music and Entertainment Hall of Fame in 2011. That same year, he received the Al Merito Award from the Arizona Historical Society in recognition for lifelong distinguished service in promoting Arizona history. In 2011, the Arizona Centennial Commission honored him along with seven other Arizonans as "One of Arizona's Most Inspiring Leaders." Included among the seven were Senator Barry Goldwater and Justice Sandra Day O'Connor.

In 2012, he was selected for the U.S. State Department's "Cowboy Hall of Fame Tour," a goodwill visit to Kyrgyzstan to visit our troops and share American cowboy culture with the people of that country.

The Historical League of the Arizona Historical Society named him one of seven "Historymakers" for the year 2014.

That same year, he received the Semper Fi Award from the U.S. Marine Corps Scholarship Foundation.

Visit us at
www.historypress.net
..
This title is also available as an e-book